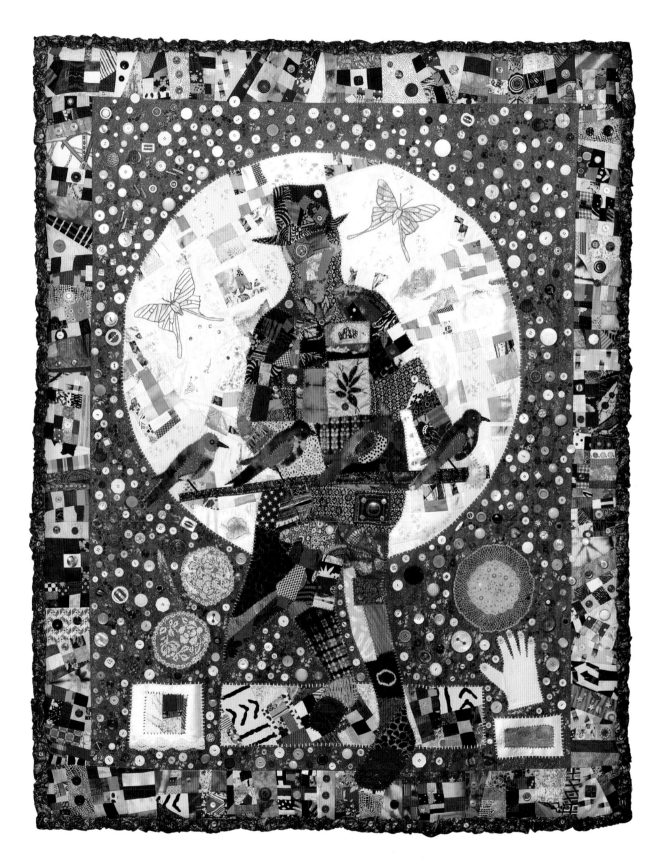

# Quilting Art

Inspiration, Ideas
& Innovative Works from
20 Contemporary Quilters

Spike Gillespie

Voyageur Press

First published in 2009 by Voyageur Press, an imprint of MBI Publishing Company, 400 First Avenue North, Suite 300, Minneapolis, MN 55401 USA

Voyageur Press titles are also available at discounts in bulk quantity for industrial or sales-promotional use. For details write to Special Sales Manager at MBI Publishing Company, 400 First Avenue North, Suite 300, Minneapolis, MN 55401 USA.

To find out more about our books, visit us online at www.voyageurpress.com.

Printed in China

Library of Congress Cataloging-in-Publication Data

Gillespie, Spike.
   Quilting art : inspiration, ideas & innovative works from 20 contemporary quilters / Spike Gillespie. —1st ed.
      p. cm.
   Includes index.
   ISBN 978-0-7603-3526-0 (hb w/ jkt)
   1. Quilts—United States—Themes, motives.  I. Title.
   NK9112.G55 2009
   746.46—dc22
                                      2009008613

Editor: Margret Aldrich
Design Manager: Katie Sonmor
Designed by: Lois Stanfield

Frontispiece: *Moonlight* by Jane Burch Cochran, *Photograph courtesy of the artist*

Title page: *Nine Patch, detail,* by Robbi Joy Eklow, *Photograph courtesy of the artist*

Acknowledgments: *Your Move* by Susan Else, *Photograph by Marty McGillivray*

Contents: *Finding a Unicorn* by Ai Kijima, *Photograph by David Ettinger*

Front cover
Top: *Iterations Number One: Aquamarine* by Deidre Adams, *Photograph courtesy of the artist*

Bottom left: *Structures #46, detail,* by Lisa Call, *Photograph by Ori Sofer*

Bottom center: *Awake, detail,* by Margot Lovinger, *Photograph courtesy of the artist*

Bottom right: *Horizon X, detail,* by Deidre Adams, *Photograph courtesy of the artist*

Back cover
Top left: *Catacombs XIII: After Klee* by Joanie San Chirico, *Photograph courtesy of the artist*

Top center: *Rose Petal Tea* by Mary Beth Bellah, *Photograph courtesy of the artist*

Top right: *By Their Hands* by Jane Burch Cochran, *Photograph courtesy of the artist*

Bottom: *Medallion* by Loretta Bennett, *Photograph by Pitkin Studios*

*For David Bennett, Dolores Gillespie, and Zvi and Nily Sofer*

## ACKNOWLEDGMENTS

I WANT TO THANK EVERYONE who helped so much to educate me while writing *Quilting Art*. My one regret was that we were unable to meet everyone profiled here in person. But whether we spoke over a kitchen table or the phone, each artist made precious time to talk at length, provide photographs, and give me a bigger, deeper, richer portrait of the quilting arts. I offer special thanks to David Bennett both for inspiring me through his art and for his ongoing kindness over the years. And another very special thanks to Ori Sofer, who, I'm pretty sure, had no idea what he was getting himself into when he said yes to the question, "Hey, want to work on this book with me?"

Ori and I both want to thank Ann Woodall and Charla Wood for their indispensable guidance and assistance during our Austin photo shoots.

Finally, I offer my deep gratitude to Margret Aldrich and Voyageur Press for recognizing the importance of the work these artists do and for choosing me to be the very lucky writer who got to paint their portraits.

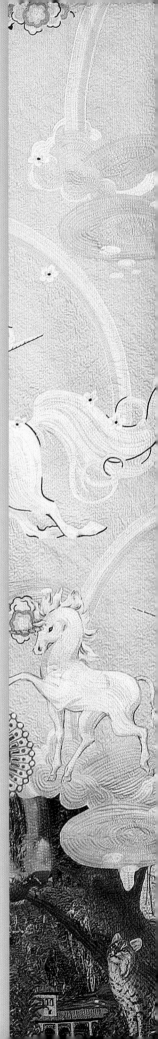

# Contents

**HORIZON X | Deidre Adams | 2007 | 25" x 25" | Cotton fabric, acrylic paint | Machine stitched, hand painted |** This piece was made for the invitational exhibit Sense of Place, part of the International Quilt Festival in Houston, Texas, in 2007. *Collection of Karey Bresenhan. Photograph courtesy of the artist.*

# Introduction

IN LATE JULY 2008, I was in Astoria, Oregon, one of my favorite places in the world. This was my third trip to the little community that overlooks the Columbia River where it runs into the Pacific Ocean, the very place Lewis and Clark finished up their journey West. For me, too, visiting Astoria was part of a bigger journey, though not my final destination. I was in the midst of a whirlwind summer packed with trips all over the country to meet with quilt artists and interview them about their passion and their process.

Those trips were part of an even bigger journey, one that began for me many years ago when I stumbled into the world of quilting. As I detail in my book, *Quilty as Charged: Undercover in the Material World*, when I first wrote about quilting, I thought I was taking a quick, surface look at the art form. My goal at the time was simply to write a short newspaper article on the topic, collect my fee, and move on.

But as many people know, once you discover the astounding, compelling universe of quilting arts—well, good luck trying to turn around and head back out the door. A friend took me to the International Quilt Festival in Houston as part of my research, and I was hooked. Suddenly, what started out as one article led me to write a whole book dedicated to passionate quilters from all walks, ranging from fans of traditional patterns to contemporary artists putting their own unique marks on the form. Along the way I spoke to everyone from dedicated hobbyists to some of the biggest rock stars in the quilting world.

That book, in turn, led to an invitation from editor Margret Aldrich to write this book, in which I narrow my focus to explore the works of artists who start out with the basic premise that a quilt is three layers and then, from there, they head off down the far less beaten path, utilizing all sorts

OTTO (BILL), detail | Margot Lovinger | 2005 | 35" x 35" | Cotton, silk, velvet, netting, and tulle, with trim, beading, and embroidery | Hand-sewn layered fabrics | "In this portrait of my partner, Bill, I combine a more formal, classical style of portrait with an honest and personal depiction of the man I love," says Margot. *Photograph courtesy of the artist*

of original techniques and concepts. From creating three-dimensional works to incorporating components one would sooner find in a hardware store than a fabric store, all of the artists I spoke to infuse their work with great originality.

This originality thrilled me. It also resonated because, though I am, admittedly, a poor seamstress and only occasional quilter, I've been a writer for decades. In this art form, I have explored various avenues, working to find my voice and pushing what often felt like limits others wished to impose upon me, limits I had no interest in adhering to. In talking with quilt artists who have chosen to ignore rules and go their own way within a discipline known for

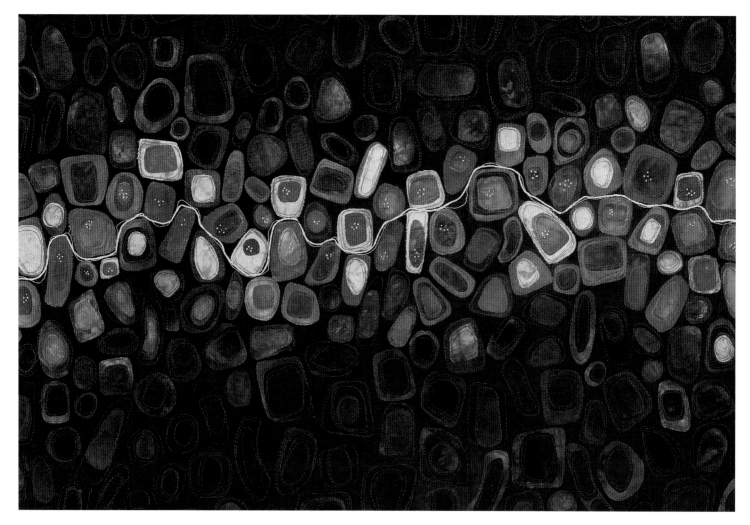

LIFE GOES ON IV, detail | Karen Kamenetzky | 2008 | 30" x 30" | Artist-dyed cottons and silks, yarns | Machine and hand stitched | *Photograph by Laurie Indenbaum*

deep tradition, I found myself in the company of kindred spirits. In fact, with each ensuing conversation, I was further inspired to remember how important it is to carve out time to pursue the passionate side of one's calling and to heed one's muse, both of which are too often too easily lost in the shuffle of doing what we must to get by day to day.

One question I put to many of the artists was this: *How do you feel about the word "quilt"?* I brought the topic up because I'd learned along the way that some consider the term a death knell when it comes to being taken seriously in the art world, while others had no trouble with it.

I purposefully posed the question carefully. I didn't do this to tiptoe around the topic—the artists I interviewed clearly weren't interested in kid-glove treatment. But over the years at the International Quilt Festival, I noted what felt like a trend. Folks would look at a quilt, and if it was not the sort of work typically associated with quilts (read: reminiscent of grandmother's house), arguments over its merits ensued—*Is it a quilt or not?* I even read an article in the local paper one year where this question was put to a festival attendee, who deemed a work "not a quilt" because, he observed, it was nothing he could put on his bed.

Spike Gillespie, at home in Austin, Texas, showing the back of her quilt *For Ori*.
*Photograph by Ori Sofer*

The way I see it, an article like that is setting up a false argument. Why ask an uninformed bystander to define a quilt? Why not ask a more pertinent question like, *How do you feel about the way quilts have progressed and moved into the art world?* Is it important to seek controversy—even, especially, if that controversy feels contrived?

So, while I wanted to honor the fact that opinions about the word "quilt" run the gamut, I did not want to collect opposing points of view and then splice them together as if there were some big catfight going on in the world of quilt artists. The answers I received were offered not to suggest that one way of thinking is absolutely right and another is absolutely wrong. Instead, I felt myself invited to contemplate how the word helps or hurts artists working to get their pieces out there for the world to see.

Let me offer a few of the responses I received to illustrate my point. Karen Kamenetzky explained her perspective: "You'll notice on my website it says *fiber artist*. It used to say *quilt artist*. I made a conscious decision to change that. In a big way it had to do with marketing. I was in a gallery in a city in the Midwest when I showed the owner my card, which said *quilt artist*. She said, 'Lose the word quilt because it sets up walls. It's confusing to people who assume you're making bed quilts.' I wanted to be seen as an artist, not a quilt artist. Maybe it has to do with not wanting to feel stuck in the insular world."

Deidre Adams has similar feelings. "In no way do I want the word *quilt* associated with my work. It ghettoizes you. The perception is that quilts are not real art. This is the row we have to hoe if we want to play in the art world. Mixed media textiles are what I make."

On the other hand, Pam RuBert is fine with the word. "I think some people get tired of it—when they say they make art quilts and someone says, 'My grandmother made quilts. . . .' I don't mind if people call mine quilts—structurally my work is pretty much a quilt. But I don't call myself a quilt artist. I'm an artist that makes quilts. I come from an art background and I saw this as a medium. I wasn't a quilter that decided to do art. It was a conscious choice. I've heard that galleries and museums don't want to call them quilts because it's too homespun sounding. But I find it an advantage—to be a painter and stand out in that world is hard, whereas quilts are a niche."

Joan Dreyer, who often doesn't even use fabric, although she does use layers and stitches, is not too worried about how her work is labeled. "I remember having these discussions in art school—a professor asking, 'What is the artist's intent?' I'm less concerned with putting a label on it. I almost don't care in a way. I don't feel other artists have to make the same choice. For me I just need to make it for the reasons I need to make it."

That said, she adds, "If the word *quilt* is in a show, I won't do it. I'll do fiber art and fine art shows."

And, though her 3-D work is far from the roots of traditional, two-dimensional quilts, Susan Else says, "I don't have a problem with *quilt*, although I agree there's an issue with it. I don't think we should get hung up on the word. Having come from a family of fine artists and having been in the craft world myself, I understand the whole ball of wax. I think it's very complex. I think the problem is that it has a financial impact on people's ability to make a living and achieve recognition as artists. At the same time I don't think changing the words or what we call ourselves is going to change the situation. I think only time and high-quality work will change that. Fortunately or unfortunately, we're at the front end of that. I do my work; I straddle a number of areas. The quilt world has been very good to me, though they haven't always understood what to do with me. But they're supportive. The obstacles I run into are more personal than societal. I haven't run into so much anti-cloth prejudice."

As more of an observer and ardent fan than participant in the art, I found these observations caused me to examine my own thoughts on the topic more closely. In particular, I recalled once hearing a criticism of Salvador Dali that suggested his work was too accessible, commercial, and derivative, and that there were far better surrealists. But I love Dali's work, and if I were to respond to the criticism, I'd put on my defensive hat and point out that, as someone who grew up with a dearth of cultural experiences (particularly regarding fine art), I, for one, am grateful that Dali's stuff was popular enough to reach even me. The door he opened didn't take me into one Dali-centric room and leave me stuck there. Instead, it opened countless others and gave me access to still more art.

In a way, this leads me, for a moment, back to good old-fashioned utilitarian bed quilts, for which I offer advance apologies to the artists I've interviewed who might well wince at my insistence on visiting this topic in a book dedicated to art and innovation. To be certain, there is no mistaking the work of these artists for the quilts piled on my bed, these

having been made, yes, by a grandmother (not mine, but a friend's) and featuring traditional patterns. But had I not fallen in love with bed quilts, I might not have written that first little article and stepped inside the massive room of astounding possibilities art quilts present, which have, in turn, fueled a passion and appreciation so great I've fantasized about dropping all other projects and going back to school for an advanced degree in textiles. (I confess this fantasy falls into the same category as learning four languages fluently and teaching my dogs to clean the house for me.)

Don't misconstrue: I understand the need for serious artists using quilts as a medium to differentiate their work from—let me be extreme here—Sunbonnet Sue and county fairs. I guess, then, what I would most wish for is that we will reach a point where viewers, gallery owners, and collectors drop comparisons and consequently lose any need to debate the worthiness of what is clearly a unique, progressive art form. Just as pop music and classical music are each built upon the same scales and yet are never mistaken for each other, I believe that traditional quilts and nontraditional quilts should be able to coexist peacefully in their separate realms.

In the meantime, one disheartening thing I discovered as I interviewed so many artists was that for now, perhaps because the word *quilt* still too often does conjure *craft* and thus leads to marginalization, making a full-time living as a quilt artist is damn near impossible. Some of those I interviewed work full-time gigs and squeeze in studio time before and after work and on the weekends. Some take handwork with them to meetings to work in a little multitasking. Some have spouses who provide support (on all levels). And at least one, for now, is borrowing money to build her business, though as of this writing she's considering returning to a desk job.

This, too, resonates with me. To support my art and my kid over the past twenty years, I've resorted to a sort of patched-together circus of freelance gigs that has covered the spectrum from pet sitting to performing weddings to commercial writing and editing gigs that have had me

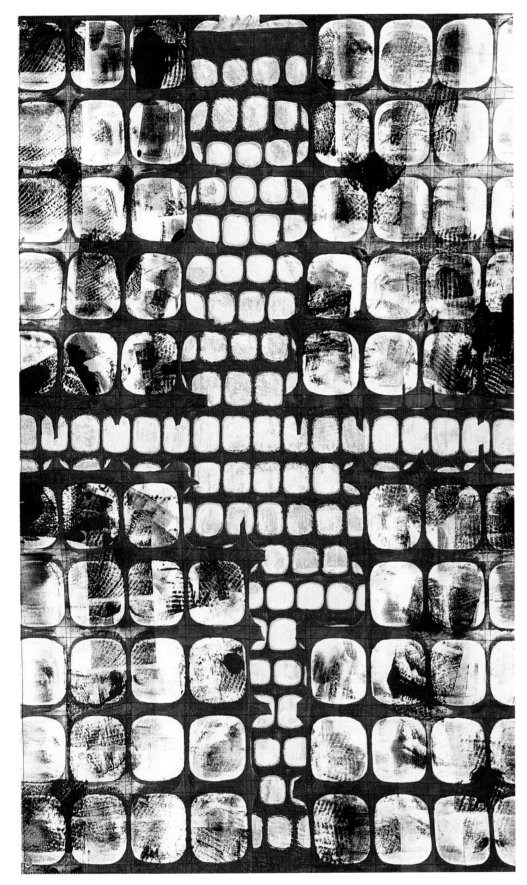

**ORANGE CONSTRUCTION FENCE SERIES #41** |
Jeanne Williamson | 2006 | 28.5" x 47" |
Cotton, fabric paint | Monoprinted, painted,
hand stamped, machine stitched | The fourth
of four pieces that explore the sun shining through
ripped construction fences, this piece contrasts two
different construction fence patterns. *Photograph by
David Caras*

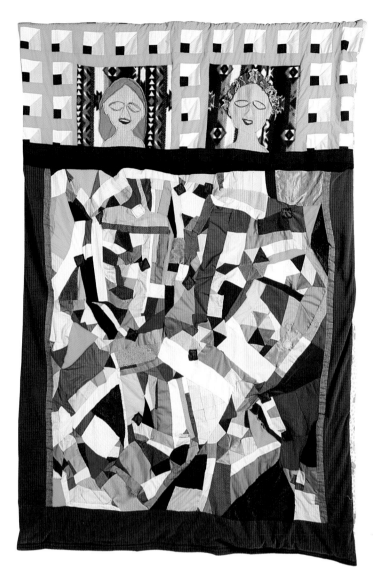

**WEDDING GIFT | David Bennett | 2006 | 78" x 62" | Recycled fabric | Machine pieced and quilted |** David Bennett made this quilt as a wedding gift to the author, his sister-in-law at the time. The marriage didn't last, but the quilt—and the friendship—did. David and Spike still meet annually to discuss life and quilts in Astoria, Oregon. *Collection of Spike Gillespie. Photograph by Ori Sofer.*

Getting back to Astoria. On that trip, I spent some time with my friend, David Bennett, whom I met when I married his brother. The marriage failed, but my friendship with David, who has been quilting for over three decades, only grew stronger. I last visited on the heels of David's completion of a big project—forty quilts created for the Victory Over Child Abuse camps, an Oregon summer camp program created to promote healing to young survivors of sexual abuse. Donors bid on David's quilts, with the quilts themselves then going to the campers and the money paid for them being used to defray camp costs.

David's quilts are a Venn diagram of art and utility, and though recipients of his work often contemplate which wall to hang them on, they are heavy-duty constructions, typically made of recycled fabrics, which he prefers double as blankets for warmth or picnics. What I love about his work is that I can feel a direct connection to his inspiration as I look out the bay window of his second-story bedroom in Astoria. There, the view is of the mighty Columbia, a hilly tree line, and a sky-scape that is forever changing from hour to hour. Which is to say that at any given moment, the natural scene in front of him is the very thing he mirrors in his work. And it was the sound of his work to which I fell asleep at night, the busy sewing machine, which went on long into the pre-dawn hours, as the nocturnal artist stayed awake "just one more hour" to move forward on yet another piece.

Other stops along the way included visits to Missouri, New Jersey, New York, Seattle, Denver, and Washington DC, where I met with a myriad of quilt artists exploring their own avenues of inspiration. Ori Sofer joined forces with me to photograph many of the artists and the work for this book. Time after time we found ourselves immersed in yet another fascinating tale of how an artist came to quilting arts, often transitioning from some other medium.

We also enjoyed some awesome hospitality. Pam RuBert and her husband, sculptor Russ RuBert, gave us a tour of their humongous studio and took us out on their boat where they taught Ori to water ski, a lesson cut short by a sudden thunderstorm that left us soaked through. Many others hosted

doing everything from describing thousands of calendars for a website to writing dry white papers for corporations to creating copy for a pamphlet informing prepubescent girls about their reproductive systems. I've grumbled along the way but never stopped pursuing my more creative endeavors. Likewise, the artists I spoke to all demonstrated a drive that might, at times, be set aside temporarily for work necessary to pay bills and time needed to raise kids. But, in the end, the muse will not be silenced, and, thankfully, the art continues to flow.

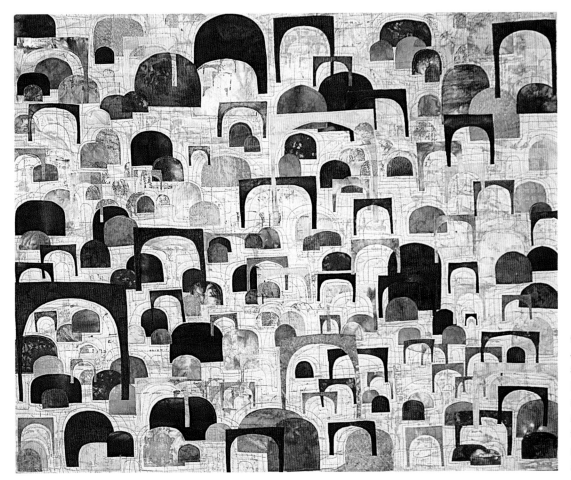

**CATACOMBS XVIII: VERDIGRIS |**
**Joanie San Chirico | 2006 |**
**37" x 45" | Cotton, dye, paint |**
**Hand dyed and painted, appliquéd,**
**machine stitched |** In addition to
creating textile works, like this piece
from her *Catacombs* series, Joanie
also paints and takes photographs.
*Photograph courtesy of the artist*

us, schlepped us to and from airports, gave us places to stay and feasts to nourish us along the way. These trips were transformative for us in many ways, as we deepened our knowledge of art and witnessed the creativity that pervades these artists' lives, even beyond their studios. As Ori put it, while on the RuBerts' boat, in a statement that summed up the thrill of our journey-in-process and has become an anthem for both of us: "Quilting changed my life!"

On the following pages are profiles of twenty artists. Among them are a good mix of those who embrace the word "quilt" and those who eschew it, those who strive to support themselves financially through their art and those who aren't worried if they never sell a single piece. Many began in another medium—very often painting—before transitioning to textiles. Some are famous, others are working toward that goal, and a few aren't terribly concerned with whether or not their work reaches a greater audience.

They come from all over the United States. And all of them share that same thing that attracted me to quilting art in the first place: a feverish passion for translating vision into tangible, thought-provoking works of art. Each prompted not only inspiration but a real belief that when you are willing to put your mind and hard work into a project, and when you allow yourself to wander outside the bounds of preexisting rules and parameters, you will experience all of creativity's freedom and all of its attendant joy.

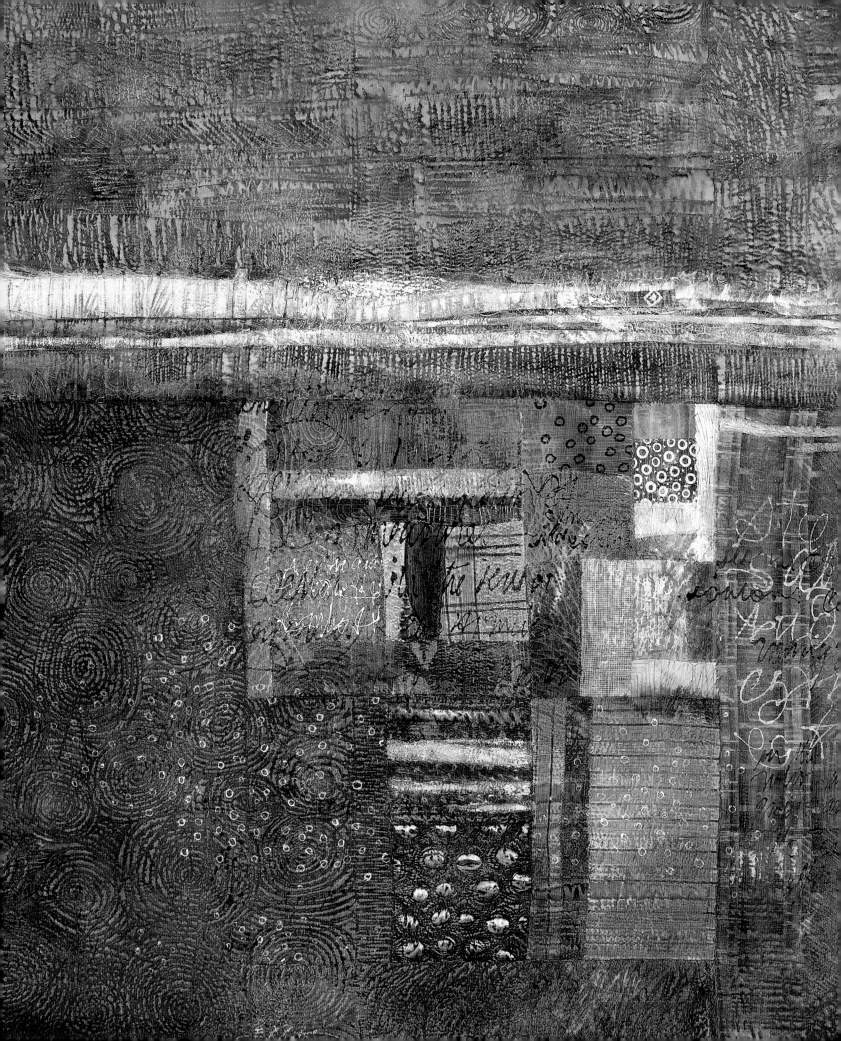

# Deidre Adams

DEIDRE ADAMS MADE HER FIRST QUILT in 1992, when her son was a newborn. The Colorado artist chose a Log Cabin pattern from Eleanor Burns's *Quilt-In-A-Day* series, which, for Adams anyway, proved to be a misnomer in part because she didn't have access to one full, uninterrupted day. "I would carefully put my son down for a nap, tiptoe downstairs to the sewing machine, and be lucky to get one line sewn before he'd wake up and start crying."

Though she managed to complete that quilt eventually, finishing did not bring with it some *aha* moment that she'd found her life's calling. "I really enjoyed the process, but I didn't think to myself, 'Oh my God, this is the best ever,'" she says. "That came later as I did more."

After that first Log Cabin, she did a few more traditional quilts but soon got bored with those projects. "One day I decided to put my own spin on a traditional design," she says. Pleased with the result, she then decided to take a workshop with Nancy Crow.

"That was very much an eye opener," Adams recalls. "Nancy is a dedicated artist. She didn't tolerate nonsense, and the workshop was not for the faint of heart. A couple of people cried. The main things I got from Nancy were the ideas of dedicating yourself to your art and working in a series, of taking an idea and working it over and over and developing and exploring it."

Though she still wasn't thinking that she'd found her life's art, at the time, Adams was becoming more immersed in the culture of art quilting. In her day job as a graphic designer, she spent two years working for *Quilter's Newsletter Magazine*. This exposed her to the larger community and examples of what others were doing.

**CHRONICLES 3 | Deidre Adams | 2007 | 36" x 36" | Cotton fabric, acrylic paint | Machine stitched, hand painted |** Deidre Adams says, "My compositions are abstract, yet they contain elements evocative of structure, with vertical and horizontal divisions reminiscent of windows and doorways, or with strong horizon lines that reflect the idea of landscape." *Collection of Lone Tree Library. Photograph courtesy of the artist.*

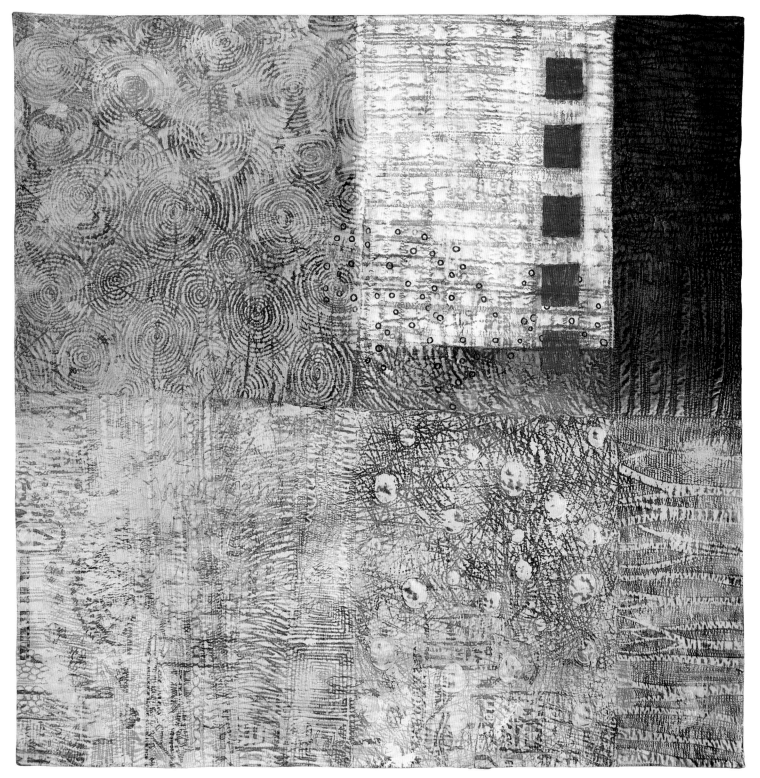

**CHRONICLES 5** | **Deidre Adams** | **2007** | **36" x 36"** | **Cotton fabric, acrylic paint** | **Machine stitched, hand painted** | Deidre's textile works are essentially paintings that are done on a custom canvas of her own making. She explains, "My inspiration comes from the idea that nothing lasts forever, and I'm exploring the idea of time and change, with layers of imagery that reflect the ebb and flow of life itself." *Collection of Lone Tree Library. Photograph courtesy of the artist.*

Adams found her unique artist's voice while doing some piecework. "I had a piece that was not working for me, and I set it aside," she recalls. "I don't know what gave me the idea, but I decided to put some paint on it. I was very excited about the effect created when paint sits up on the surface of the stitching."

She never did finish that piece, but she took the idea and decided to try her technique on another piece. This one started out with large pieces of light blue and white fabric, pieced in a simple manner, which she planned to use as a quilted canvas for painting. "I brought it on a retreat with my critique group and everyone teased me. 'What is that? A rag rug? A baby quilt?'"

She persisted, and it was upon completing that second piece that painting became her process, one that has grown more defined in the five years since. She often doesn't know what a piece is going to end up like. "I do lots of little sketches and doodles," she says. "I make little color compositions in my sketchbook from swatches cut from magazines." She might start with one of these sketches for the basic idea for a piece, but it might be very different when finished.

Adams hates to throw anything away. "I have all these little scraps from past projects. When I'm stuck for ideas I start piecing them together. It's a very meditative process. If I'm not working from a preconceived idea, I'll start with one of these. I'll just put one up on my design wall, and I'll find bigger pieces to put around it until I have something that more or less looks like what I want."

Once she's got those pieces sewn together into the top layer, she then adds batting and backing and begins the quilting. The stitching is one of the most important parts of the process because this is where the texture of the piece is created. Then it's time to add layers of paint, which gives her work a truly unique aesthetic and also provides Adams with some artistic freedom. "I don't have to freak out and worry about what it's going to look like in the end," she says, "because I can always change it. First I paint an entire layer of white to knock back the color of the fabric. And then I start planning my color scheme."

Deidre Adams shows off some scraps saved from finished projects. *Photograph by Ori Sofer*

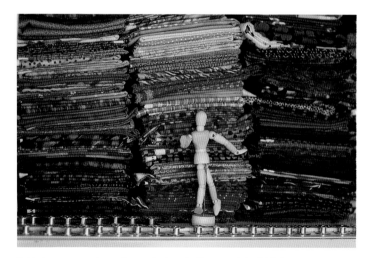

Deidre keeps a massive, well-organized stash. *Photograph by Ori Sofer*

While painting, she works on the quilt both horizontally on her design table and vertically on the design wall. "I go back and forth," she says. "The earlier stages are horizontal because it's wet and sloppy. After the first few layers, it won't bleed through to the back. That's when I put it on the wall."

It occurred to her recently that part of her process is facing off with her inner critic, "every single time." She'll begin painting, and the voice will start up. "The early stages of the painting can be agonizing—a period of despair. But I always work through it until I'm happy with it."

Though Adams sometimes teaches, she's not interested in teaching her process. She explains, "I think everyone should find their own voice. I'm glad to help people explore that, but I'm not interested in teaching them to make a quilt that looks like one of mine."

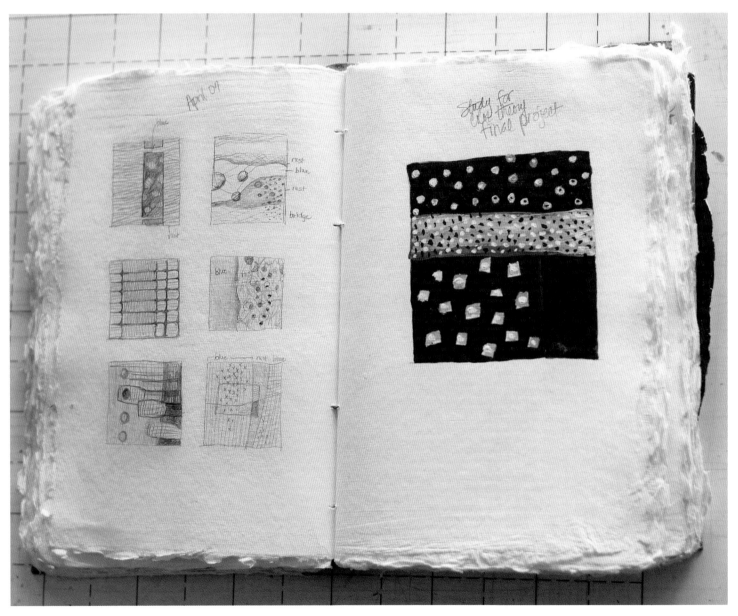

Deidre Adams's journal of ideas and inspiration. *Photograph by Ori Sofer*

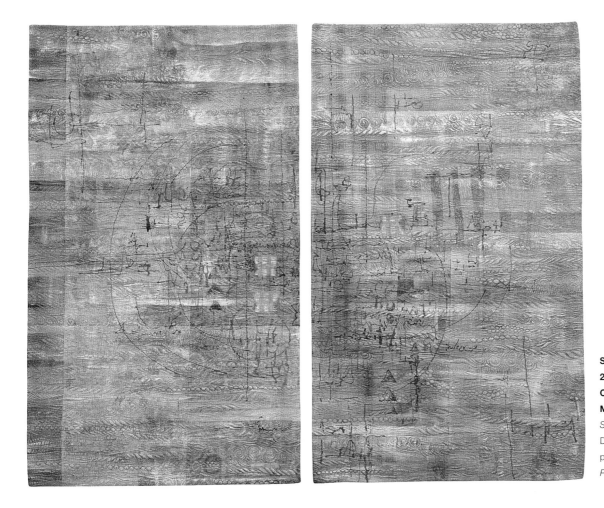

SOLSTICE | Deidre Adams |
2004 | 42" x 51" (diptych) |
Cotton fabric, acrylic paint |
Machine stitched, hand painted |
*Solstice* was the first piece that
Deidre made using her technique of
painting on a stitched textile "canvas."
*Photograph courtesy of the artist*

She keeps a lot of projects going on at once, in part to circumvent creativity blocks. "If I'm stuck on one piece, I'll put it aside and work on something else. I like having my studio in my bedroom because some days, after having ignored a piece for weeks, I might see it in the mirror when I'm brushing my teeth and suddenly know what I have to do with it. Or I'll see something in a magazine that triggers an idea that allows me to finish."

## ADVICE FROM *Deidre Adams*

If you want to do this as an art, I think you need to try a lot of things, but work hard to find your own voice. Don't just copy other people. Do the work and find your own way. Everyone asks how I do my free-motion stitches. When learning to do free-motion quilting, you have to do one entire quilt you don't give a rat's ass about, and then you can be fearless. After you get used to it, it's completely automatic.

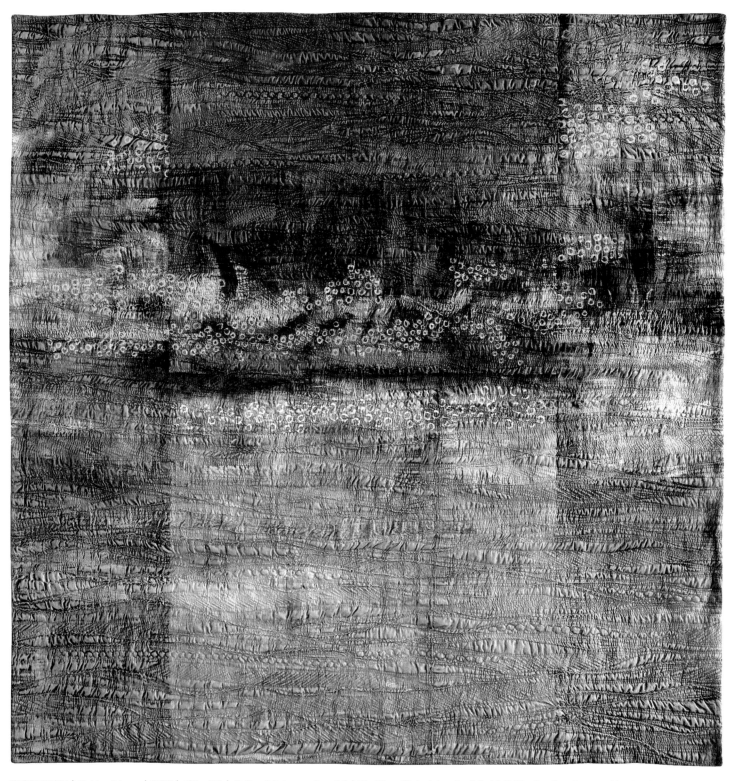

**PASSAGES V** | **Deidre Adams** | **2006** | **42" x 42"** | **Cotton fabric, acrylic paint** | **Machine stitched, hand painted** | Deidre describes *Passages V* as "an abstract piece with a loose reference to landscape," and says texture and mark-making were her focus in the work. *Collection of the Wichita Center for the Arts. Photograph courtesy of the artist.*

**PASSAGES IV** | Deidre Adams | 2005 | 28" x 22" | **Cotton fabric, acrylic paint** | **Machine stitched, hand painted** | "This is an abstract based on landscape," explains Deidre. "The spiral motif often appears in my stitching patterns. After using them for several years, I became aware that they are mirrored by the bales of hay that I often see while taking one of my photography road trips." *Photograph courtesy of the artist*

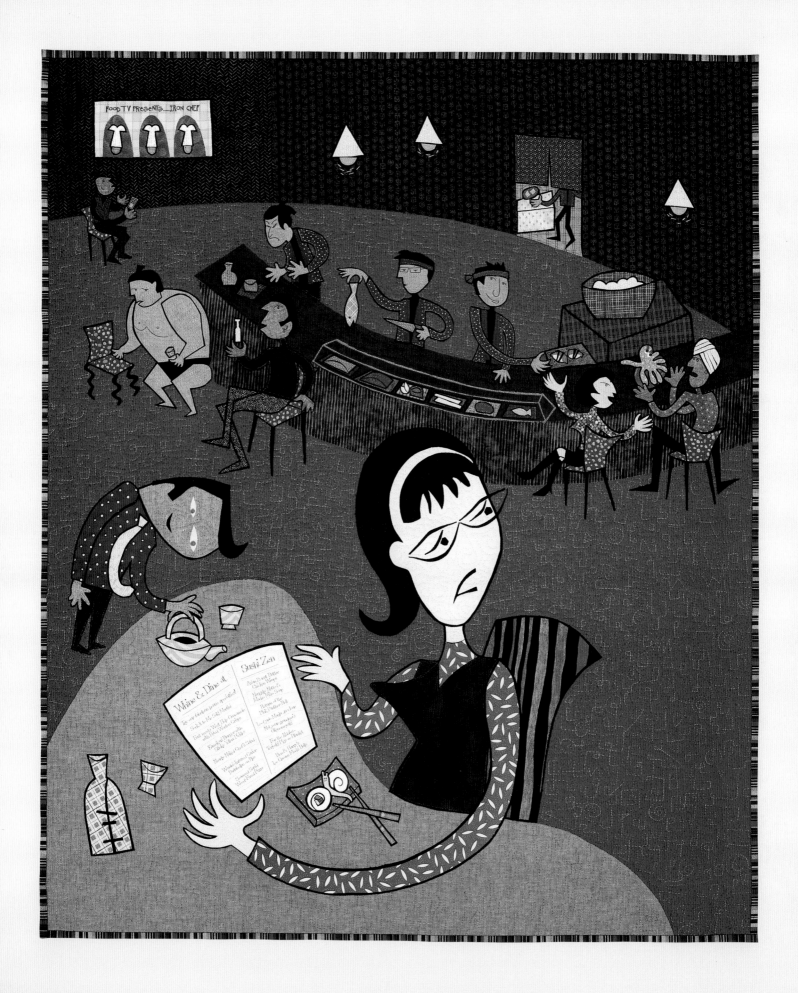

# Pam RuBert

PAM RUBERT'S QUILTS ARE BRIGHT, hilarious, and often contain numerous witty visual puns. She works in Springfield, Missouri, in an ample studio space within a massive 22,000-square-foot warehouse—it was once a peanut butter factory—which she shares with her sculptor husband, Russ RuBert.

Her enviable space is organized but packed—with her stash, whimsical collections of old magazines, knickknacks, and sundry other curios all arranged on the furniture and industrial fixtures she and Russ enjoy scouting out at auctions.

Though her themes vary, RuBert is best known for her prolific *PaMdora's Box* series, featuring a trademark, pointy-breasted character who, in the artist's words, "views the world around her with a strange mixture of astonishment, dismay, and amusement."

Inspiration comes from RuBert's daily life, "a weird combination of worrying about important things like alien invasions or small things like being late for a date." These manifest in cartoonish scenes with "really selective surprises," often in the form of the three-dimensional embellishments she is fond of including like a zipper that becomes the toothy mouth of an alien, and cows' eyes that are literally bead-y.

Her pieces typically begin as sketches in her journal, which she then plays with while doing other things. "I think about it a lot while I exercise. I imagine my composition."

The process can take a couple of months, during which she "bops back and forth. I play with colors and refine the sketches." Once she's satisfied with a sketch, she scans it into her computer. Then she drops it into a scale drawing.

**WHINE & DINE AT SUSHI ZEN | Pam RuBert | 2004 | 50" x 40" | Commercial and hand-dyed cotton fabrics | Free-motion machine quilting |** "Has watching all those food shows like *Iron Chef* on TV made us all a little more crazy?" wonders Pam. "Who knows, but I love Asian fusion food and watching people at restaurants." *Photograph by Russ RuBert*

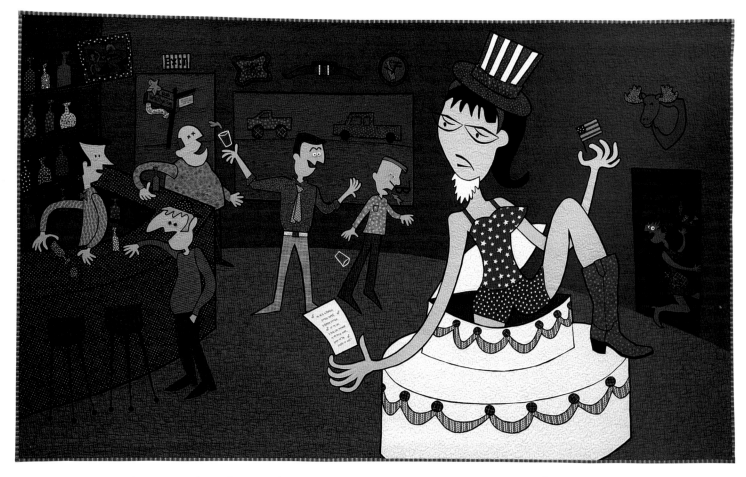

**THE SINGING TELEGRAM | Pam RuBert | 2006 | 49" x 81" | Commercial and hand-dyed cotton fabrics, vintage buttons | Free-motion machine quilting |** Many of Pam RuBert's quilts contain personal stories and (often zany) details. "In college I had the crazy job of delivering singing telegrams," says Pam. "The weirdest one I delivered was singing 'Yankee Doodle Dandy' at a surprise party for an Iranian man who had just earned his U.S. citizenship. The party was at Club Brassy Toe in Brazito, Missouri, population sixty-eight. I still think about it every time I drive by that town." *Photograph by Russ RuBert*

Detail of Pam's free-motion stitching. This is the back side of the image of PaMdora on *The Singing Telegram*. Photograph by Ori Sofer

When she's got scale established, she'll cut her fabric. "Mostly I use commercial fabrics that are preprinted. Every city we've gone to, I get in a cab or on a bus and go to a fabric store."

She then plays with the fabric, sticking it to her design walls in rudimentary outlines, working to establish composition. "Composition is tricky," she says. "You have to think of light and dark. I get most of my inspiration from illustrations and paintings. I have a lot of artists whose work I look at that aren't fiber artists. I look at kids' books. I look at photography. And I often look at films, too. I'm thinking, *How do you fit all of the elements into one image? How do you show time in an image?*"

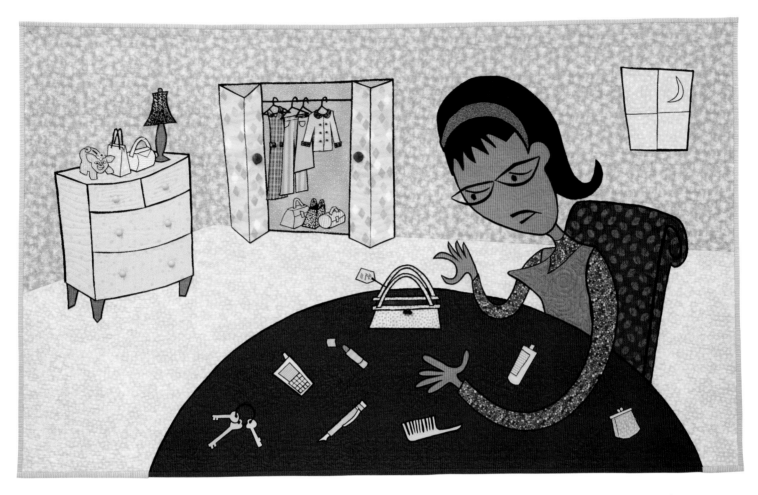

**THE VINTAGE PURSE** | Pam RuBert | 2005 | 36" x 58" | **Commercial and hand-dyed cotton fabrics, vintage buttons** | **Free-motion machine quilting** | An homage to accessories, this piece explores the pluses and minuses of groovy old bags. "I love cute little vintage purses," says Pam, "but there's never enough room for everything." *Photograph by Russ RuBert*

Detail from *The Vintage Purse. Photograph by Ori Sofer*

Detail from *The Vintage Purse.* "I like to put personal mementos into my work," Pam says. "The piggy bank on the dresser is one that was in my grandmother's house, reminding me that instead of buying more purses, I should save my money!" *Photograph by Ori Sofer*

Next, she fuses all the elements of her composition to the quilt top. She'll sketch out a draft of how she wants to stitch the layers together in advance, but ultimately she executes the quilting freehand, usually in patterns to match a piece's theme, another opportunity to slip in some subtle humor. For example, in a piece that brings together Egyptian pyramids with food pyramids, her stitches, upon scrutiny, reveal themselves to resemble hieroglyphics.

RuBert had always been involved in art—she and her husband met in a sculpture class, and she'd worked in ceramics, digital illustration, painting, and photography before turning to textiles as her primary medium.

"Around 2002 I started finding out about art quilts. I saw an article in the paper—our quilt guild was having a big show. I walked in and saw a quilt by Cynthia England. I was shocked, I'd never seen anything like it before."

She began taking one-day workshops, joined the guild, and started researching quilts, influenced by artists like Jane

Pam's spacious studio is flanked with helpful design walls. *Photograph by Ori Sofer*

Sassaman. "I still couldn't figure out what I wanted to do. I kept seeing all this abstract stuff, but I'm not that good at abstract. I lose interest. I'm into the concept and story line."

Then someone gave her a book by an artist named Shag. "He does these real retro paintings, and I had this huge epiphany—*I can do art that can have a story and be entertaining*. I decided I should be doing what I do best, humorous cartoons. I think there's a dearth of humorous art. We need more things to laugh at and lighten the day."

One series was inspired by a pun she'd carried around for a few years: *Wish You Were Hair*. She began sketching "these people with hairdos that are monuments of the world." One character sports a 'do that is the Eiffel Tower. Another has the Sydney Opera House on top, and another, Niagara Falls.

Then there is *Super Dilemma Market*, in which a confused PaMdora attempts to navigate a grocery store packed with choices. "I was thinking about *The Odyssey* and about going through all these temptations—*Do you buy organic? Low fat?* It's so hard," RuBert says.

Another technique she uses to infuse lightness is to take something ordinary and make it absurd. "A pretzel isn't that funny," she says. "But it's a funny idea. If you make it plaid it's even funnier." And it's funnier still if the pretzel is being held up by PaMdora, who happens to be attempting a yoga pose that mirrors the pretzel.

Sometimes, RuBert tackles more serious topics with her humor. In one piece she's working on, she wants to illustrate how "we've messed with Mother Nature and now

Pam, in her Springfield, Missouri, studio. *Photograph by Ori Sofer*

she's going to fight back. I think she'll be fighting some scary robot guy that represents technology. A lot of my stuff plays out like a movie in my head. I try to imagine different viewpoints. So there are all these endangered species in the audience watching. And I think PaMdora will be coming in late because humankind is late waking up to problems."

As with her other work, this piece will evolve over months before RuBert has it just the way she wants it. "That's what makes the process interesting," she says. "I don't like to just have a simple concept. I like that there's this continually developing conceptual element. The conceptual is what's exciting and keeps me engaged."

**ADVICE FROM** *Pam RuBert*

To me, scale is a big issue. Things that are bigger than yourself have a bigger emotional impact. I think you get a bigger response. I want to create this fantasy world that people get sucked into, it's bigger than them. But then you have to think about construction if it gets too big. And you have to think about shipping issues.

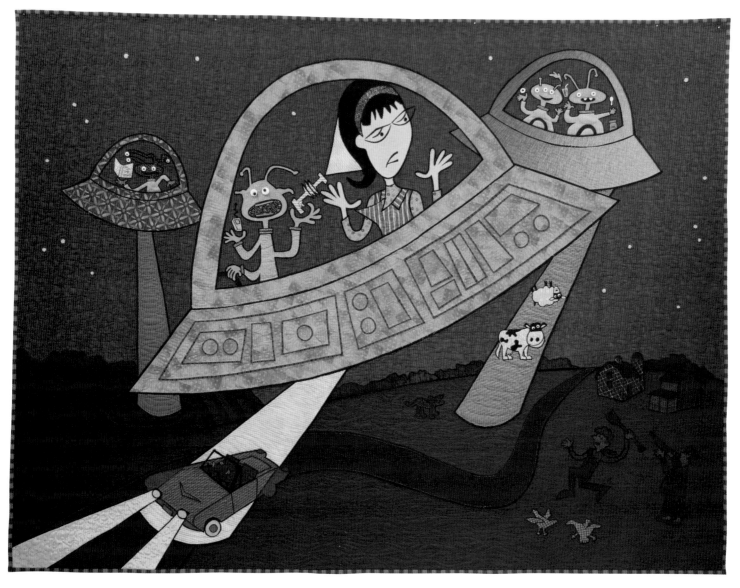

**ALIEN INVASION** | Pam RuBert | 2006 | 53" x 72" | Commercial and hand-dyed cotton fabrics, handmade beads | Free-motion machine quilting | "I had a lot of fun making this," says Pam. "Since I eat a lot of junk food on road trips, I gave the aliens mini white donuts and Tang for the long trip to Earth." *Photograph by Russ RuBert*

Pam's inspiration comes from "a weird combination of worrying about important things like alien invasions or small things like being late for a date." These manifest in cartoonish scenes with "really selective surprises," like a zipper that becomes the toothy mouth of an alien.
*Photograph by Ori Sofer*

**FRESH!** | **Pam RuBert** | **2005** | **46" x 46"** | **Commercial and hand-dyed cotton fabrics, beads** | **Free-motion machine quilting, photo transfers** | Pam's humor is woven into her quilts, as evidenced by *Fresh!* "I made this quilt when my dog was a puppy, and I was on the early-morning shift," she explains. *Photograph by Russ RuBert*

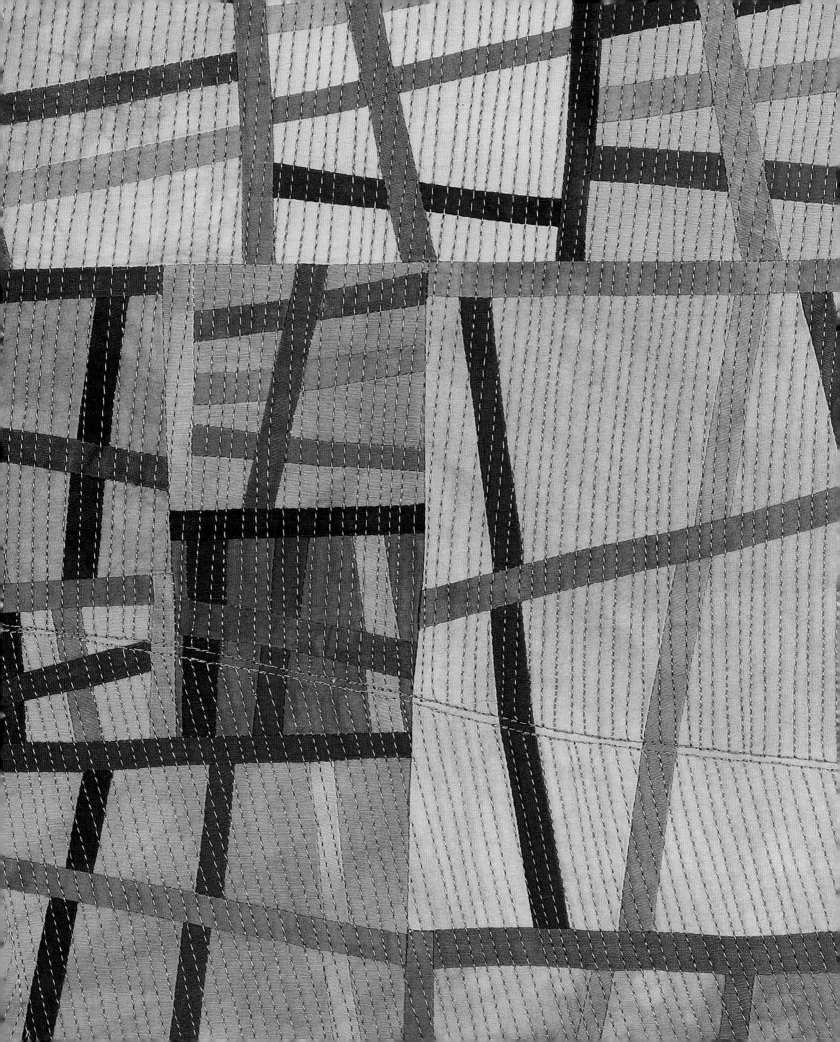

# *Lisa Call*

EVEN AS A CHILD, Colorado textile artist Lisa Call was interested in art. "When I was in grade school and high school I was always making things," she says. "I was always constructing houses out of trash, or drawing, or doing something creative."

Call first tried quilting her senior year in high school. She also considered majoring in art in college but pursued a computer-science education instead. Still, she took art classes as an undergrad and graduate student to stay connected to her art. She also made a quilt each year through college, sticking mostly with traditional patterns.

When her first baby was born in 1992, she decided to stay home with him and really focus on quilts as her medium, hoping to seriously pursue life as a textile artist. It took her about another four years, after the birth of her second child, to "get a feel for where I was going with it."

Around this time Call began taking lots of classes from different instructors teaching art quilting. "You learn a lot of technique and styles," she says, "but nothing struck me as what I wanted to do. Then in 1999, I took a class with Nancy Crow in improvisational piecing, and I knew I'd found a method that worked for me. I use a limited set of traditional techniques to create my work and push my art forward through the design and composition rather than by innovating working methods."

Call's work is, in her words, "a cross between abstract impressionism with color fields and modernism." A primary source of inspiration is fences.

"There's something about the physical structure of fences—the repetition is soothing to me," she says. "I love stone walls and brick walls, the lines and negative space. In addition to the physical aspect of those structures, I'm also

*Structures #48, detail. Photograph by Ori Sofer.*

**STRUCTURES #48** | Lisa Call | 2007 | 48" x 64" | Cotton fabric hand-dyed by the artist, cotton batting, cotton thread | Freehand-cut with pattern or rulers, machine stitched | Says Lisa Call, "As the *Structures* series matures, focus has shifted to the psychological barriers humans use to protect themselves emotionally, exploring how we hide our true thoughts and feelings with these imagined roadblocks." *Photograph by Ori Sofer*

drawn to the emotional and psychological aspects. When you put a fence up what are you saying? Are you keeping things out or keeping them in? I also think about the boundaries we have in our head, where we hide behind walls and fences. It's pretty rare to let our real selves be known, but it's a human experience to want to find connections and break down those barriers."

Call works forty hours a week as a software engineer and fits an additional twenty hours in working on her art. When she begins each new piece, she says, "I try not

to have any preconceived ideas whatsoever. I just go to my studio and make the work. When I try to force an idea or concept I generally find that my work comes out horrible. It has to come from the unconscious for me. My work is an interpretation of what I have been feeling and thinking."

She hand-dyes all of her fabrics. "I don't use formulas. I can never reproduce my colors. I enjoy it because it's a big, wet, sloppy process. Quilting is dry. My textile paintings are created using three distinct art forms—the dyeing, the composition,

and the stitching. All are different activities that require very different ways of thinking. I love all three—there's not a part of the process I don't love from beginning to end."

*Structures* is the series she's been working on for several years, and currently the collection includes nearly one hundred finished works. These speak, very much, to her love of, and curiosity about, fences. And while she says mostly the work is joyful for her, "There are some pieces that brought up some more unpleasant memories."

As an example, she points to *Structures #10*. While it is, quite literally, very dark, as the viewers' eyes move across the work from left to right, it gets lighter, and the pieces become more defined.

"I made this piece right after my husband moved out. It's my divorce quilt," she says. "I don't view the work as portraying a negative message. Women can lose themselves when married by putting everyone else first and forgetting who they are. This piece is about growth from that lost place to a feeling of knowing oneself."

A number of artists describe moments during the process when their confidence falters and they question why they're doing the work at all, only coming to love it later. Call has the opposite experience. "I don't usually feel a piece is less than successful until it's done," she says, and laughs. "While I'm making it I'm usually pretty thrilled with the work." And, once her latent inner critic recedes, she says, "Most of my work ends up being my favorite."

Call is big on using the Internet for marketing her work and selling individual pieces. Eventually, she hopes to place her larger art in corporate spaces—hospitals and hotels. "I don't have a concrete business plan in place yet," she says, but she is working on one. "In my mind, marketing is not a mystery. You make goals and work on them. I figure if I love making the art I will keep doing it and figure out how to make a living at it."

Part of keeping things demystified includes keeping accurate track of the hours she spends on each piece and pricing her pieces more or less by the square foot (with a little wiggle room to account for mitigating factors).

She doesn't have a hard time parting with the one-of-a-kind works, either. Even the divorce quilt is for sale. "I'd love to sell it," she says. "It served its purpose in my life. Now it needs to serve its purpose in someone else's life."

She's working to rebrand her website and blog, and the new version will not contain the word *quilt* because she finds the description too constraining and is sometimes unable to get past preconceived notions when using this term.

"The other day, I delivered a piece to an all-media art show in Denver," she says. "I won honorable mention and was the only fiber piece in the show. They said, 'You should show your work at the quilt gallery in town.' I thought, *Why should my work be relegated to the quilt ghetto? It belongs on the wall in any gallery—art doesn't need to be segregated by medium.*"

ADVICE FROM *Lisa Call*

Don't wait for it to be the perfect time to create art. There is no perfect time. You can do it when you have a full-time job and when you have kids in the house. There's really nothing stopping you but yourself. I get up early enough to do at least fifteen minutes before work. I get at least a couple of hours in when I get home and quite a bit on the weekend.

**STRUCTURES #10 | Lisa Call | 2004 | 35" x 52" | Cotton fabric hand-dyed by the artist, cotton batting, cotton thread**
**Freehand-cut with pattern or rulers, machine stitched |** Lisa Call refers to *Structures #10* as the divorce quilt. "I made it right after my husband moved out," she says. From left to right, the piece gets lighter and becomes more defined. "The quilt shows growth and where I wanted to be. Though it looks dark and ominous it's about a positive experience." *Photograph by Ori Sofer*

**STRUCTURES #46 | Lisa Call | 2005 | 45" x 61" | Cotton fabric hand-dyed by the artist, cotton batting, cotton thread |**
**Freehand-cut with pattern or rulers, machine stitched |** "The *Structures* series, which investigates the boundaries we use to divide our world, originated in 2001 as an exploration of human-made structures for containment such as fences and stone walls," says Lisa. "Lines of posts, negative space created between odd-shaped stones, and uniform rows of bricks were all of interest." *Collection of University Hospitals, Cleveland. Photograph by Ori Sofer.*

**MARKINGS #12 | Lisa Call | 2006 | 44" x 32" | Cotton fabric hand-dyed by the artist, cotton batting, cotton thread | Freehand-cut with pattern or rulers, machine stitched |** "The *Markings* series refers to the comfort humans derive from repetition," explains Lisa. "We are soothed by the well-known patterns that result from duplication: telephone poles in a line, a grouping of trees in a forest, our unchanging daily routines." *Photograph by Ori Sofer*

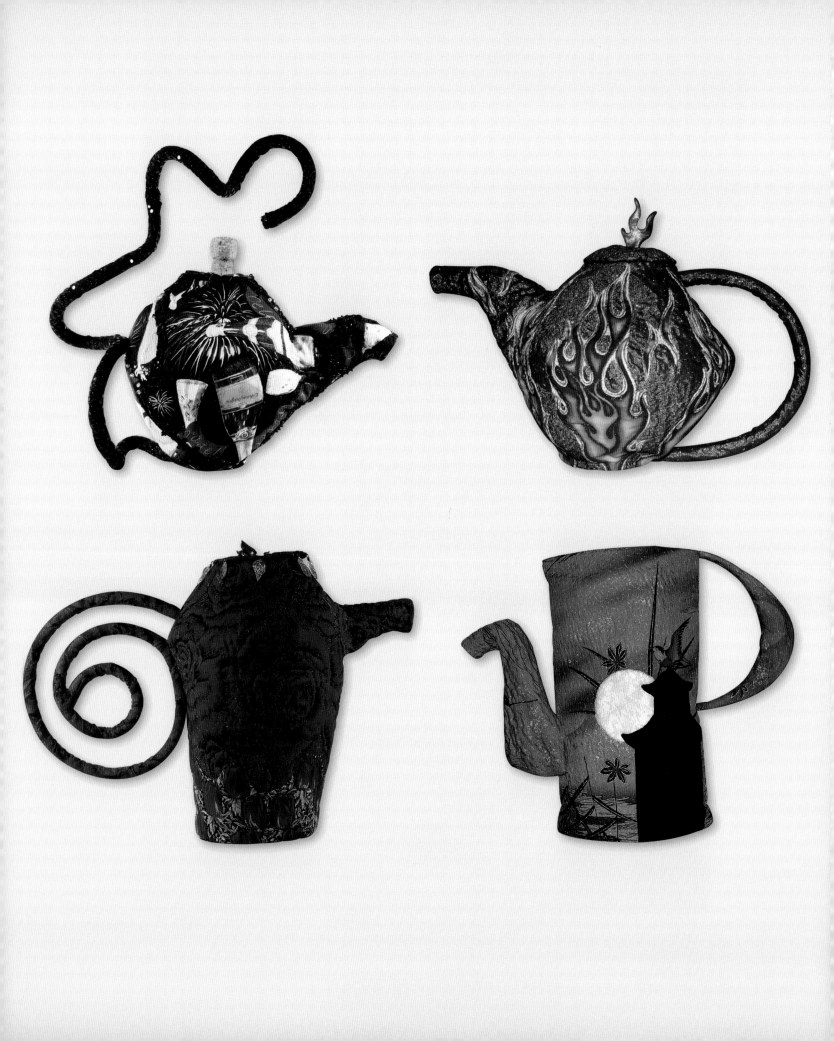

# Mary Beth Bellah

MARY BETH BELLAH GREW UP doing all sorts of handwork. "My mother's very, very creative and has done pretty much everything but quilting. I did everything but quilting."

The jump to quilting came when she moved to Virginia in 1991 and found herself in possession of a closet full of decorator fabric the previous homeowner had left behind. "I started making quilts with it," she says. "People told me it's not a good idea to use upholsterer fabric, but I didn't pay attention—I've pretty much always done whatever I wanted."

Once she started quilting, she says, "I didn't do anything else. Why would you want to?"

Though she does make some bed quilts, even when she first started out Bellah didn't go the traditional route. "I was just cutting and layering. I almost never used patterns. I'm not good at making pattern quilts or following directions. I'm always stepping out into my own designs."

These days, Bellah focuses on three-dimensional quilted sculptures, pieces that don't match some folks' definition of *quilt*. She doesn't care. "I have no problem if work happens to be 3-D or freestanding," she says. "My perception and interpretation of *quilt* is the technique. If that is expanded into a different format that's okay with me. Other people may have issues with it. I don't."

She enjoys working in series, and her *Tea-isms* series features over thirty quilted teapots. The series began when, contemplating a gift for her mother's birthday, she considered the teacup collection her mother had recently inherited from *her* mother

*Clockwise, from top left:* **TEA PARTY (2001, 12" x 13" x 8"), HOT TEA (2002, 7.5" x 11" x 7"), TEA HOUSE OF THE AUGUST MOON (2002, 13" X 15.5" X 4.5"), ROSE PETAL TEA (2002, 13" x 17" x 7.5") | Mary Beth Bellah | Commercial cotton, buckram, boning, copper mesh, vinyl tubing, cotton batting | Hand-built base, appliquéd, quilted, embellished |** Mary Beth Bellah says, "My quilt teapots are freestanding and would be 'functional' were they not made from fiber." *Photographs courtesy of the artist*

**RISING WATER | Mary Beth Bellah | 2006 | 28" x 48" x 38" | Commercial cottons, cotton batting, plastic armature, thread | Machine and hand stitched, embellished |**
Mary Beth created *Rising Water* for Quilt National 2007. She's comfortable, she says, with pushing the envelope to "carry the viewer a few steps further out in my exploration of that quilt word."
*Photograph courtesy of the artist*

and struck upon the idea of a quilted teapot because, "I wanted to make something meaningful and link them."

Because she likes wordplay so much, she decided to incorporate "tea-isms"—phrases that refer to tea. "Some are pretty obscure, like *dragon well*. But there are a lot of phrases that are ubiquitous like *tea time, a soothing cup of tea, tea for two*. The teapots were an extension of those sayings. I'd think, 'That'd be a great teapot,' and I could see what it would look like. As I experimented with materials to get the right effect, they lured me in."

She's also done a series of postcard quilts. "The postcards are done on the machine—those are like little edibles. They can be done really fast. It's not a unique idea, and it's not my idea. When my daughter went off to college I wanted to send her stuff. I email and talk to her, so I didn't have anything to tell her in snail mail. So I started sending quilted postcards."

Bellah does most of her work by hand. "The times that I do step into using a machine are when it's more practical, like with the grid pieces. Those are constructed into long strips and diced into two-inch squares. It depends on what the quilt wants or needs. The more you work in series or familiarize yourself with materials, you own their properties so you don't have to spend as much time learning how to manipulate them. The manipulation comes more easily so you can spend more time with expression."

And, she's a Quilt Whisperer. "I've had people say, when they watch me work, 'You're talking to that fabric.' It's a conversation. A lot of times I have a clear idea of what that piece wants to be. You know when you get hung up and stall out—it's telling you that you're going the wrong way. A lot of times you need to let it gestate. It's like almost every process— some back part of your head is working on it," she says, adding that this is why ideas and solutions "pop out at weird times."

She made a conscious choice to hang on to her full-time job at the University of Virginia, rather than worry about making a sustainable income off of her art. "I do not sell a lot of pieces. This is how I figured out it's okay: I work a forty-hour week. For a long time I had my heart set on creating enough of a portfolio and image of myself that I could quilt

**A SUM OF MY PARTS** | Mary Beth Bellah | 2007 | 21" x 17" x 5" | Commercial cottons, cotton batting, copper mesh, boning, recycled shipping armature/wire, thread, chenille yarn, paperclips | Shaped armature, machine and hand quilted and embellished | This hand-quilted piece was created in response to Mary Beth's local quilt guild's "challenge quilt" for a biennial show. The challenge was to create a basket quilt that could be filled with whatever you wanted to put in it. "I of course went 3-D with the concept and chose to use novelty fabrics, which represent the important people/things in my life which sum up my world," she says. *Photograph courtesy of the artist*

full time. But I like my salary and my benefits and the college my kids go to. I give forty hours a week to my mortgage and kids. Whatever I come home and work on is whatever I want, I don't have to sell it. I don't care because I already did forty hours. With that kind of mindset I don't really worry about sales, and I can focus on the work itself."

She does take her quilting to work with her. "The way I've incorporated it, I carry a basket everywhere," she says. "In the basket are my calendar and purse and odds and ends and always some component of a quilt. I do a lot of handwork whenever I'm sitting. If I'm waiting for somebody or in a meeting that doesn't require me to interact, I'm usually quilting. I keep a lot of pieces going at once, like multiple Parcheesi pieces. If it's portable, it goes with me. I keep working, otherwise you get nothing done. When it gets too big to travel, that's what I work on at home."

She likes commercial fabric but isn't limited to fabric stores. "My favorite place to shop is Goodwill. Part of it is because I'm really cheap. Part of it is because you can find such unusual things. And I love Freecycle." (The Freecycle

**CAUGHT | Mary Beth Bellah | 2003 | 4" x 10" x 7.5" | Commercial cotton, velvets, lamé, copper mesh, vinyl tubing, cotton batting | Shaped armature, appliquéd, hand quilted |** Evocative of the expression "caught red-handed," *Caught* is another example of Mary Beth's exploration of quilted sculpture. *Photograph courtesy of the artist*

Mary Beth hangs out with her goat buddies, Peanut Butter and Ernie. *Photograph by Jessica Bellah*

**GOAT GIRL POSTCARD 5** | **Mary Beth Bellah** | 2005 | 4" x 6" | This mini-quilt, part of Mary Beth's quilted postcard series, features a couple of her favorite four-legged subjects—her pet goats. *Photograph courtesy of the artist*

Network, www.freecycle.org, is an online, worldwide network promoting reuse and recycling among members who give and take used items to and from one another at no cost.)

On the other hand, if it's a choice between dyeing her own or buying commercial fabrics, she'll go with the latter. "If it's twenty-dollar-per-yard velvet, I'll suck it up and buy it. I know a lot of people get hung up on having to paint or dye their own fabric. I don't get hung up on that. You don't have to grind the pigment. I have an enviable stash. I have ten bookcases full of fabric. I could easily win a stash contest. All my quilt friends bring their spouses over so they can go home and say, 'You're right, honey, you don't really have that much.'"

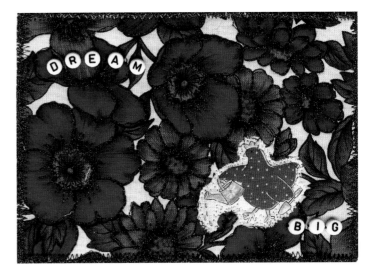

**DREAM BIG** | **Mary Beth Bellah** | 2005 | 5" x 6" | Another in the mini-quilt series, this photograph-sized piece features fabric, beads, and stitching. *Photograph courtesy of the artist*

**ADVICE FROM** *Mary Beth Bellah*

My perspective on materials is, I look at everything wondering how can I incorporate it. Nothing is taboo. I think a lot of times people get hung up on known uses instead of being open to possibilities. I can spend hours in a hardware store and it's not for hardware. The last time I had a piece in the International Quilt Festival, it had barbed wire. The next year they had a rule just for me—no more sharp objects on your quilts.

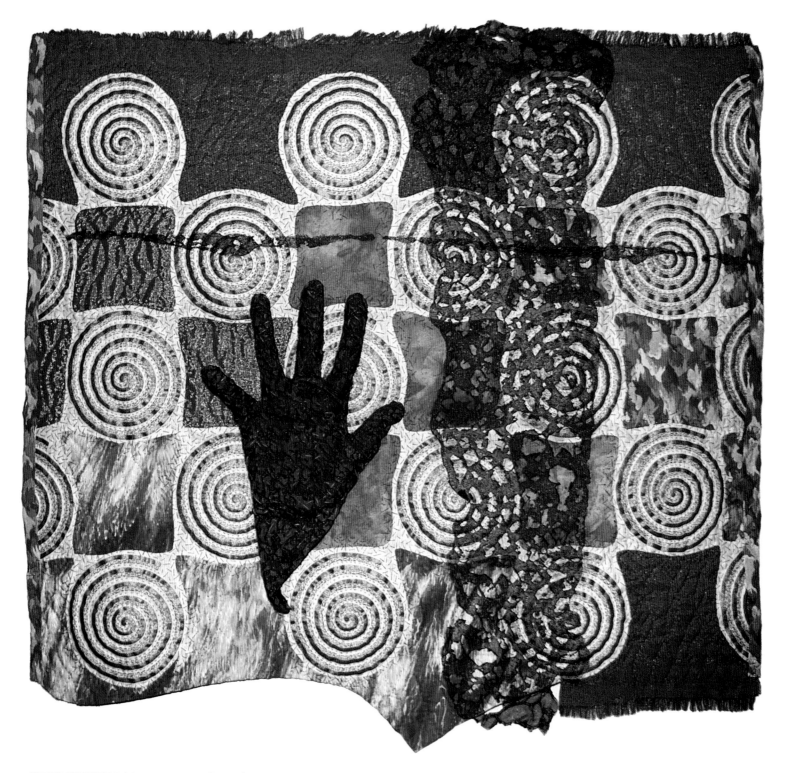

**HOT TO THE TOUCH | Mary Beth Bellah | 2003 | 24.5" x 26" x 2" | Commercial cotton, organza, copper mesh, cotton batting | Shaped armature, appliquéd, hand quilted |** The artist often includes hands in her work, as seen in this three-dimensional quilt. *Photograph courtesy of the artist*

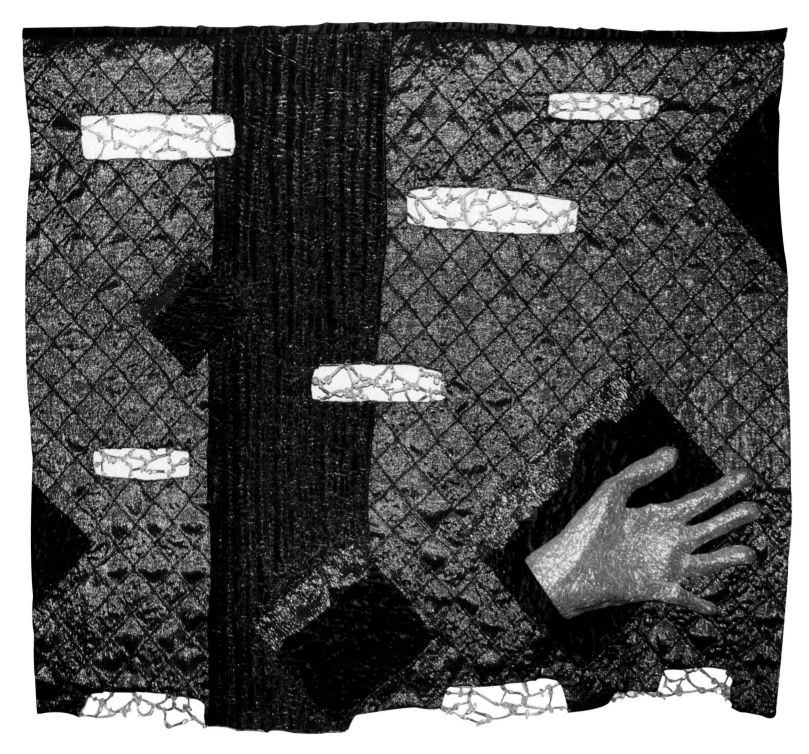

**COLD TO THE TOUCH** | Mary Beth Bellah | 2003 | 23.5" x 26" x 2" | Commercial cottons, satin, copper mesh, cotton batting, glass beads | Shaped armature, appliquéd, hand quilted, embellished | A counterpoint to the piece *Hot to the Touch*, which features warm reds and oranges, *Cold to the Touch* uses snowy white and cool blue to convey feeling. *Photograph courtesy of the artist*

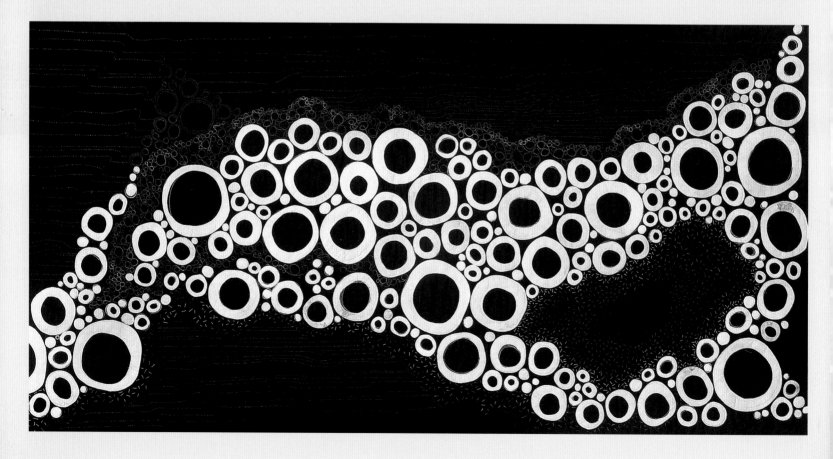

# Sarah Williams

SARAH WILLIAMS MOVED TO THE Washington DC area in 2006 and spent more time away from her studio than in it, which wasn't, ultimately, as bad as it might seem. Because in the end, so much time away from her artwork put it squarely in the absence-makes-the-heart-grow-fonder category.

"I've been going through textile and gardening magazines. It's been a time of looking at where I want to go, looking at what's important me. The two years have helped me focus—I know I'm much happier in the studio, and I have to get back into the studio and focus on my work."

Williams spent the past couple of decades moving around the country to places her husband's academic career took them. The most recent of those moves takes Williams and her husband to Lawrence, Kansas, where she will have a chance to create a studio she can really settle into, one she hopes will feature lots of windows and light from the north.

Williams grew up taking classes in painting and drawing and later in jewelry and ceramics. While working on her degree in textile design, she got her first taste of the fabric sandwich. "I took a class in manipulating fabric. They gave me a sewing machine, I free-stitched, and I absolutely loved it," she remembers. "Weaving takes so long from concept to finished project. That's why I started looking at quilting—it was faster. And you can manipulate things."

After a twenty-year hiatus from working with fabric, she returned to her artwork in 1998. Williams was living in North Carolina when she transitioned from

**Top left: EXCITEMENT | Sarah Williams | 2001 | 15" x 40" | Cotton canvas, paint | Painted canvas cut apart and reconstructed |** In *Excitement*, Sarah aims to capture the moving parts of nature and the parts of nature that are moving. "Nature is astonishing in its color and movement." *Photograph by Michael I. Williams*

**Bottom left: SEAFOAM | Sarah Williams | 2005 | 35" x 68" | Cotton | Raw-edge appliqué |** A trip to the Pacific Northwest provided the inspiration for *Seafoam*. "While walking on the beach in Oregon I noticed the foam that washes onto the sand," says Sarah. "What wonderful organic circles." *Photograph by Michael I. Williams*

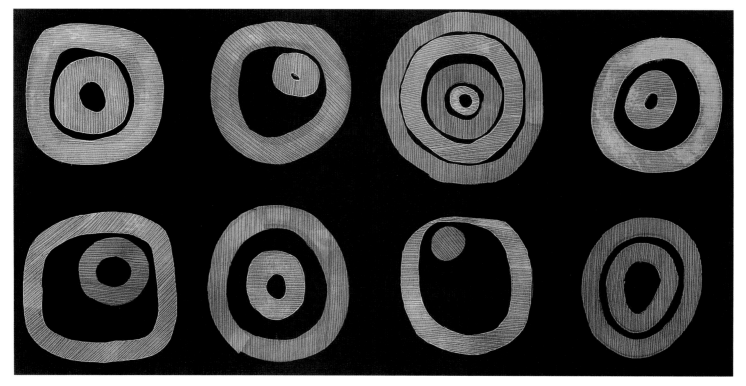

CIRCULATION | Sarah Williams | 2003 | 37" x 73" | **Black cotton discharged with bleach** | **Machine pieced and stitched** | Sarah has been to enough places to understand the truth about life's adventure not being a destination but a journey—or in her case, many journeys. "Each circle, each stitched line represents the many different journeys I have taken." *Photograph by Michael I. Williams*

an office job to working full time on her art. "Four years earlier I lost my sister Lisa in a car wreck and realized life is short and you have to pursue your passion. So off I went and started taking classes to learn different techniques. Until then, I'd only made traditional bed quilts. Now I was exposed to the whole art-quilt world." She was encouraged by friends to enter shows. In 1999 she was rewarded with her first solo show at the Durham Arts Council, showcasing twenty-eight works. "It was very encouraging to see my work hanging in a gallery space."

A move in 2000 to Milwaukee brought her close enough to Chicago to attend Professional Art Quilt Alliance (PAQA) meetings regularly, where she met a lot of well-known quilt artists who Williams says "set the bar high. They were what I was aspiring to be." The hour trip, each way, to Chicago provided good networking time with three fellow artists. More ideas came to Sarah with each trip.

In 2002 a move took her to Athens, Ohio, home of the Dairy Barn Cultural Arts Center, venue for the biennial contemporary quilt show, Quilt National. Williams laughs telling a story about a course she'd taken, prior to the move, aimed at helping participants from all walks to focus on and realize their dreams. One assignment was to write down goals for one, five, and ten years in the future. "One of my goals was to get into Quilt National. I obviously wasn't specific enough. I wound up on the administrative side—as soon as I went to the Dairy

Sarah working in her home studio. *Photograph by Ori Sofer*

Eventually, Williams went from a volunteer position to being put on the payroll. In all her time at Quilt National, she learned a lot behind the scenes. "I did have my art hang in the Barn, but never in Quilt National. I did get to design and hang the show. All of the art quilts soon became good friends."

She also got to see the inner workings of the jury process. "Judging is so subjective. I realized you could make your best work and really believe in it, but, depending on the mood of a juror, it might be rejected." She offers the example of a jury she knew of that was invited to judge a show one cold, dark winter. The jury "picked mostly warm-colored quilts, very few cool-colored quilts," she says. "You could've made a fantastic blue and green quilt, but it wouldn't have gotten in because the jurors were looking at it from where they were at."

Circles are Williams's most recurring theme. She uses various techniques and processes to create works featuring them. The exploration of circles won't be completed any time soon for her. She says. "So much in life is unresolved. The circle gives me a good feeling. It's so settling. It's a grounding symbol for me. Circles are completion."

Williams isn't concerned with making statements with her work. "I don't do edgy work. I don't do political. Pretty is what makes me happy. You should do art for yourself first. Sometimes I wish you didn't have to title your work or put information about it on a card because when you do the audience reads the card and thinks, *Oh I didn't see what the artist wanted me to see.*" She feels art should be personal to each viewer and not influenced by another's vision.

Barn and said, 'What can I do?' they put me right to work on QN '03." Hilary Fletcher, who served as Quilt National's project director from 1982 until her death in 2006, became a mentor and good friend over the next four years of Sarah's tenure at the Dairy Barn. She encouraged Sarah to work in the studio as much as possible when she wasn't at the Barn.

ADVICE FROM *Sarah Williams*

Go to your studio and have fun!

**CROCOSMIA | Sarah Williams | 2005 | 37" x 73" | Cotton
| Appliquéd top on pieced background |** As with many of her pieces, *Crocosmia* was inspired by nature. "My mother gave me a handful of Crocosmia—'Lucifer'—bulbs for the garden," she says. "Their striking beauty had to be captured in a quilt." *Photograph by Michael I. Williams*

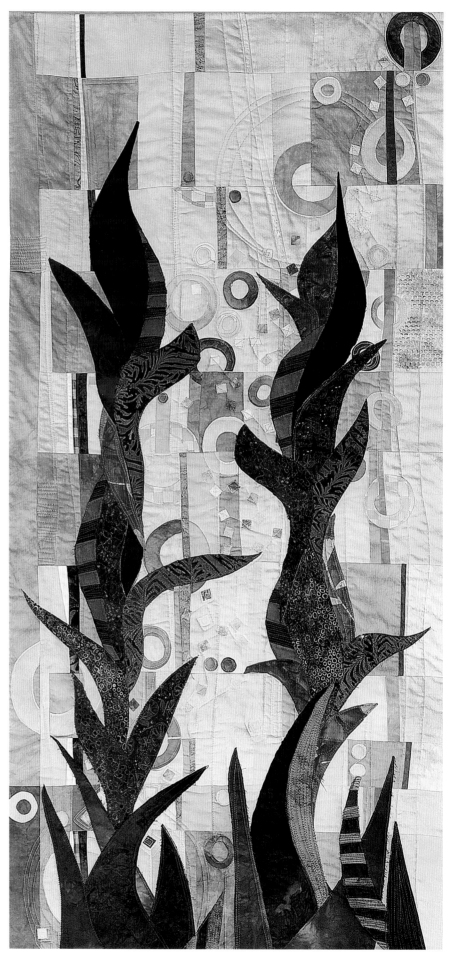

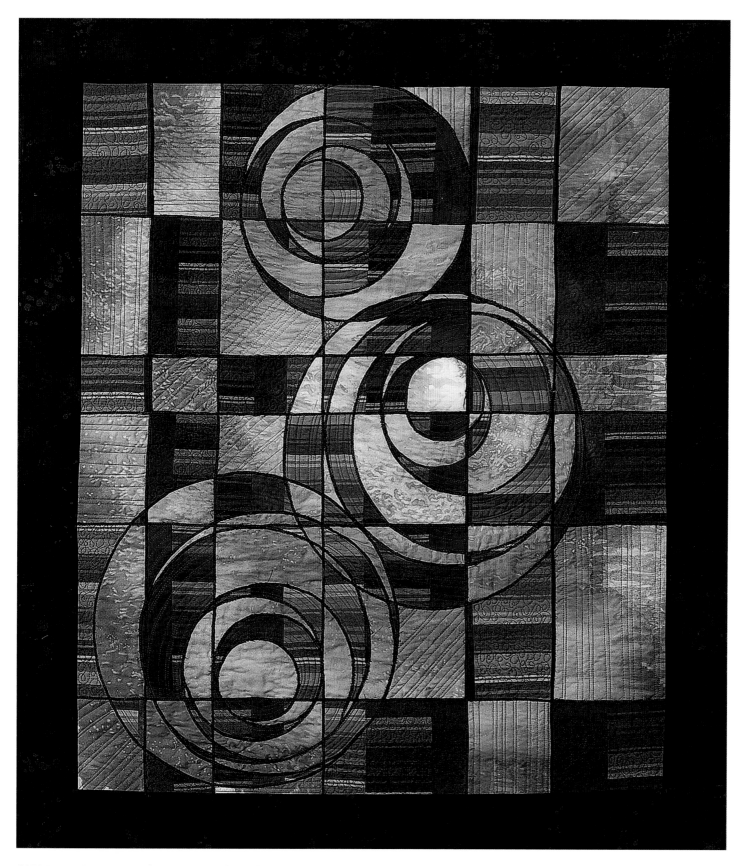

**CONCENTRIC CIRCLE GAME** | **Sarah Williams** | **2000** | **32" x 36"** | **Cotton** | **Raw-edge reverse appliqué** | Of this piece, Sarah explains simply, "There's pure joy in circles." *Photograph by Michael I. Williams*

# Angela Moll

"I LOVE, LOVE, LOVE THE VISUALS of the handwriting," says Angela Moll, a Santa Barbara, California, artist who has created a series of quilts featuring words in cursive, designed to evoke the secret diaries kept by women. "I'm interested in visually expressing the constellation of thoughts and feelings that exist around the act of writing in your journal and the connotations that it has."

Moll says she could have used another medium, such as painting, for her art but specifically chose fabric because that would "give me an intimacy of what happens in a private place, in the home, something pursued by women. Men have also kept journals, but secret journals are more of a woman's thing. Quilting allowed a surface for me to play with paint and dye but also end up with a stitched piece of work that connects with this whole intimacy."

She first learned to sew in Madrid, where she grew up before moving to the United States in 1988 to pursue a PhD in medieval literature at Berkeley. "I've sewn all of my life," she says. "I must've been four years old when my grandmother decided I had to have practical skills and started me on samplers."

The sewing lessons stuck, and by the time she was sixteen, Moll was making wearable art. "I wanted to dress my own way, clothes intended as works of art. You take into account movement. That's where I was coming from."

Quilts did not cross her radar until she'd been in the U.S. for six or seven years, but once she saw one, she decided to make one of her own. "I really love this country, and I thought this is an American tradition, it's a way to take this tradition and make it mine. Of course I didn't make a quilt like the one I'd seen. As soon as I got my materials I did something else."

**SECRET DIARY 20: GETTING ENOUGH, detail | Angela Moll | 2006 | 37" x 54" | Dyes on cotton, paint | Machine pieced and quilted, screen printed and painted |** Angela learned to write and sew at about the same time. Her passion for both has stayed with her. In the *Secret Diaries* series, she says, "I use screen printing as a means of bringing together my love for long handwriting and for the stitched line." *Photograph by Thorsten von Eicken*

Though she enjoyed the process, Moll felt, at the time, that ceramics was going to be her "main thing." Then she studied Chinese calligraphy and thought that was going to be it, but she says, "not being Chinese was a huge obstacle."

Returning to ceramics didn't seem like an option—a back injury made the work too painful. "It was about the same time I discovered that something existed with three layers, batting, and stitching through it," she says. "I needed a change. I got into quilting and thought that could work."

The first time Moll entered her quilts into Quilt National—a biennial international exhibit of contemporary, innovative quilts held in Athens, Ohio, in the Dairy Barn Cultural Arts Center—she got accepted. "That actually happened quickly," she recalls. "The next time I got rejected. It was a mixture of acceptance and rejection from day one. I view jury submissions much like a lottery because while I do my best to submit good work, other elements, such as the combination of jurors and the total pool of submitted work, come into play, resulting in mixed outcomes."

She has sold some of her work, but she says, "My focus is more on sharing within this art community. I just made a conscious choice on making the work as good as I could and sharing it through exhibits and publications. To market intensely I would have to spend this much time and make that much money—it doesn't work for me. My focus is more on contributing to the community and the body of work. I've been focusing on opportunities for visibility and not necessarily ones that are commercially more attractive. It's just a simple personal focus issue."

Moll says ideas often percolate a long time before manifesting for her. "The ideas are cooking all the time. Maybe I have them on the back burner and then maybe I

**SECRET DIARY 17 | Angela Moll | 2005 | 57" x 16" | Dyes on cotton, paint | Machine pieced and quilted, screen printed and painted |** In *Secret Diary 17,* Angela plays with the scroll format. "The pages of my secret diaries are composed of actual journal entries screen printed on fabric," she says. *Photograph by Thorsten von Eicken*

**SECRET DIARY 9** | Angela Moll | 2004 | 33" x 38" | **Dyes on cotton, paint** | **Machine pieced and quilted, screen printed and painted** | "I have a concept or an idea I want to explore in a series, and then I set up a slightly different set of formal premises for each piece to see how I can best express my idea," Angela explains. "*Secret Diary 9* represents yet another format— the codex." *Photograph by Thorsten von Eicken*

say, 'It's time.' This idea of writing and journaling on fabric and using it as a visual metaphor was there in my mind for four or five years before I worked on it. Then at some point I said, 'Okay, now it's time for me to work on this idea.'"

When the time is right, Moll says she will "go into it and produce variation after variation until an idea exhausts for me. I use it in thirty pieces or whatever—a good deal of quilts will have that same one idea. I will keep tweaking visual aspects until I'm ready to move on."

Moll's process is broken down into components to allow her to be a sort of one-woman assembly line. "I love screen printing," she says. "So I screen-printed a lot of fabric. I chose my graphic idea, and I went in and made a whole bunch. Next step, I make compositions. Maybe I produce a bunch of tops. I spend months in composing mode—line and weight and form and color. Then I say enough of that, and I go into a phase where I edit the ones I'm not interested in, modify them, and put on the batting and backing and go into a bunch of quilting. Then back to the printing stage. I may make five or six or eight at a time. It may take me months."

She finished the *Secret Diaries* series in 2008 and has begun contemplating her next series. "I'm in the exciting transition process," she says. "I'm exploring different options, going back to my stash of ideas, and seeing what's coming. It doesn't mean that a couple more pieces in the diaries series won't come out. But I've done what I wanted to do with it."

Top left: *Secret Diary 11*, detail.

Bottom left: *Secret Diary 18*, detail.

Angela Moll has a flannel-covered wall in her studio, which she sticks pieces of fabric to as she builds her compositions. *Photograph by Thorsten von Eicken*

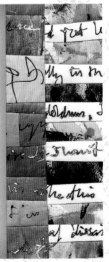

**ADVICE FROM** *Angela Moll*

I would encourage people to just basically look within themselves and do things their way. Who cares what is the wrong or right way? Do it your way.

An artist is allowed to do what the artist wants. I find that compelling. It hasn't always been like that. In the Middle Ages the scribes and illuminators weren't doing what they wanted to do, they were doing what they had to do. Today that's not our idea of what art is about. I like that so much.

**SECRET DIARY 11** | Angela Moll | 2004 | 38" x 41" | **Dyes on cotton, paint** | **Machine pieced and quilted, screen printed and painted** | "I keep journals, compile field notes, and I make quilts," Angela says. "It often strikes me how very similar those activities are. How the sentences snake along the page in much the same way as a line of stitches meanders through the fabric." *Photograph by Thorsten von Eicken*

**SECRET DIARY 18: UP TO SPEED** | Angela Moll | 2005 | 46" x 56" | Dyes on cotton, paint | Machine pieced and quilted, screen printed and painted | In *Secret Diary 18*, Angela was trying out a different way to build up the image, which, she says, "is not clear to me if it shows much in the final product." The different approach resulted in a denser, smaller-scale overall texture than her previous work. *Photograph by Thorsten von Eicken*

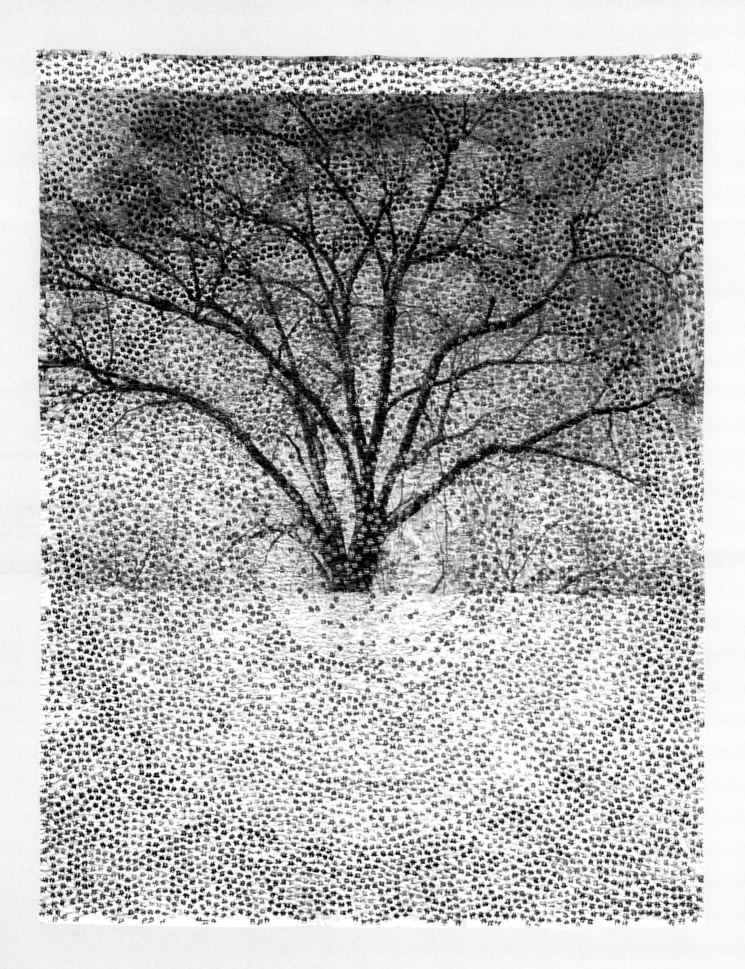

# Joan Dreyer

JOAN DREYER KNEW WHEN SHE was twenty-three that she wanted to go to art school. She also knew she wanted to focus on raising her kids and staying at home while they were young. To reconcile her goals of being both mother and artist, she began taking night classes and, over the course of seventeen years, got her bachelor's degree in fine arts. Then, at forty, she decided she wanted a graduate degree. And so, the week before her youngest child headed off for college, Joan, who lives in New Jersey, began classes at the Tyler School of Art at Temple University in Philadelphia, where she received a Masters of Fine Arts in Fiber.

"When I first started out as an undergrad, all the courses dealt with technique," she says. "First silkscreen, then weaving. The way the system is set up, you're learning technique. I think part of art school should be about psychology. In graduate school they expect you to have your act together. But first exposure in undergrad is about technique and then about process. There's nothing wrong with that, but that's not where I'm at anymore. I realized I needed to make a leap into the art world. For quilters it's about process. If you stay in the quilt world and have to think about layers, it's very confining. For me, art is about the form it takes and about the content and message. I feel like a lot of quilters are stuck in the form. A lot of it is about beauty and decorating your home. But if you're going to call yourself an artist, the content is more important, and you're forgiven more if it's not well constructed or the edges are raw. If what you're saying is good, you're an artist."

**TREE OF LOSS | Joan Dreyer | 2005 | 68" x 53" | Digital print on cotton, thread | Hand stitched |** *Tree of Loss* is part of Joan's *Grief and Mourning* series. "I decided to use the willow tree for imagery, since the willow tree has been used historically by women in needlework mourning samplers and memorial cloths," she says. "I photographed a willow tree in winter and purposely cropped it in an 'uncomfortable' manner—no trunk to keep it steady, since we all feel 'unsteady' when we experience a loss. It has 'hatch marks,' or counting 1-2-3-4-5, stitched into it—since there are five stages of grief." *Photograph by D. James Dee*

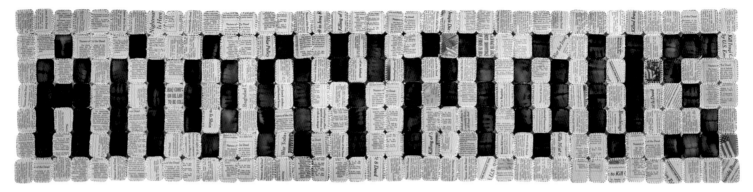

**ANONYMOUS** | Joan Dreyer | 2008 | 12" x 51" | **Dental x-rays, newspaper, thread** | **Hand stitched** | Joan began clipping the names of dead U.S. soldiers from the *New York Times*, "because I felt that just glancing over them did not honor the dead enough. In the past, women would make memorial samplers to honor dead family members. I decided to make a contemporary memorial sampler. I used dental x-rays because they represent individuals (each x-ray is unique), they are used to identify bodies, and they make me think of 'everyman' and how we all contribute and sacrifice to better our world, though our contributions and sacrifice are not always acknowledged." *Photograph by Peter Jacobs*

*Anonymous*, detail.

Joan Dreyer's home studio. *Photograph by Ori Sofer*

For the first seven years of her career, it was important to Dreyer to get her work into juried shows. That work, she says, was of the process-driven variety. Then she connected with her mentor, Carol Westfall. "She came along at an important time in my life," says Dreyer. "She'd say to me, 'I know you're making quilts, but you're in art school, you're an artist.' She's the one who challenged me to think what that means. She wanted me to think, *Did I want to make a quilt that goes into a home or goes into the Museum of Modern Art?* Her belief in me, saying the sky's the limit—she would plant these little seeds. But she didn't push me. She understood that to be an artist, it has to come from within, and you have want it."

When she first decided to refocus and move from process to content, Dreyer made a series called the *Grief and Mourning* series. "Grief is what an individual experiences, and mourning is the public thing," she says. "The series was based on a personal experience. My daughter had a friend who died very suddenly. I really couldn't help my daughter. I thought, *I need to deal with what's going on inside of me.*"

In grad school, she decided to tackle another body of work, one that "talked about issues of bigger social concern. Abu Ghraib was happening. And this flag-waving stuff was going on. I thought, *Does it mean you're a better citizen for waving flags?*"

The work she created, the *Homeland* series, is powerful and graphic, and it causes an instant, visceral reaction. "It's not that I'm trying to get in people's faces," she explains. "It's that I get to throw issues out there so people have to think about them. I'm putting ideas out there and challenging them to maybe think differently. It was very exciting to me."

Not all of her peers embraced her concept. "Some of my critiques in grad school would get heated—I found kids in their twenties or thirties saying, 'You have to take a side.' Older students appreciated that it was kind of ambiguous, that you as the viewer had to think about it."

During this time, she acquired a large cache of discarded dental x-rays. They spoke to her. "Victims are identified by x-rays, but these did not have IDs with them. They became everyman because you can't identify them. And yet they're like snowflakes. It kind of looked like humanity to me."

Using the unthreaded needle on her sewing machine, she perforated the edges of the x-rays then hand-stitched them together using wire. One piece is an American flag. Another piece, for which she stitched the x-rays to the names she clipped from the paper of U.S. soldiers killed in Iraq, reads ANONYMOUS when held up to the light.

X-rays and newspaper are not the only nontraditional supplies Dreyer has used. "If I have an hour or so I wander Home Depot, not the art store or fabric store or craft store. I found this great radiator screening that can become like a batting. It's a mesh, it's stiff, and you can attach things to it."

Still, she's not interested in putting things together just for the sake of being different. "Rather than randomly picking stuff, you have to think about the content," she says. "Why are you using nails or staples? Materials should serve the content of the piece."

Once she's completed a piece or series, Dreyer is comfortable with moving on to the next project. "I truly get what I need as I go," she says. "Once it's finished it's totally an object. I need it to go out into the world and have a life of its own. There's all this stuff happening when it's made. Then I have to go on to the next thing. It's like a child. You raise a child and launch it into the world. It's no longer a part of me."

ADVICE FROM *Joan Dreyer*

Having a mentor was huge for me. If you run into somebody in your life that you have access to, think about approaching them and making it a little more formal and asking, "Will you be my mentor?" If I hadn't had Carol, I don't think I would've done as much as I've done. It was great. Carol gave me great opportunities, and I had to work for that privilege, carrying her art, helping her with installations. I was happy to do it. We're now more like friends. She said, "I hope your career surpasses mine." It makes me want to be generous to the next generation.

**BANNER** | **Joan Dreyer** | **2008** |
**109" x 60"** | **Digital print on cotton,**
**paint, thread** | **Hand stitched** |

"*Banner* is an exploration of the fine line
between patriotism and propaganda.
Everyone is ready to wave a flag, but not
many people consider what sacrifice goes
into creating a democracy and allowing
freedom to all citizens. I made my flag of
x-rays, showing bones and human tissue,
to show that real bodies (and people!)
must be sacrificed for our ideals. I placed
the 'Code for the U.S. Flag' . . . as a
'maze' around the flag. I see the code as
strict rules telling us how to be 'correctly'
patriotic—and yet I subverted what it says
by making my own flag and *not* following
the rules. Aren't there many ways to be
patriotic? Shouldn't there be freedom of
expression even in patriotism?" *Photograph
by Peter Jacobs*

**CALENDAR OF LOSS PRESENT | Joan Dreyer | 2005 | 30" x 24" | Digital prints on cotton with ink | Hand stitched |** *Calendar of Loss Present* is part of the *Grief and Mourning* series. "Rather than a real calendar with a grid and days, I felt that grief does not stick to a schedule or normal time, so I did not make a grid at the bottom," says Joan. "Instead, the circular stitching refers to the rings of a tree trunk—the way the tree tells time. In addition, the circular stitching refers to life and death and the 'circle of life.'" *Photograph by D. James Dee*

# Loretta Bennett

LORETTA BENNETT IS THE YOUNGEST of the Gee's Bend quilters, a group that no longer needs an introduction. "Discovered" in the late nineties by Bill Arnett, a folk-art collector, the artists catapulted from poverty and obscurity, scraping by in a poor Alabama community, to international fame.

"I grew up watching a whole lot of people quilting and piecing," says Bennett of her introduction to quilt making. "My mother first of all, my aunt, and my grandmother, and since we lived so close together, quilting was part of our daily routine. I had to help my mother do a little quilting—mostly threading needles. As I was getting into my teen years I was drawn to it. I wanted to be like my mother."

The first quilt Bennett made was a Flower Garden pattern, popular in the early seventies. She recalls, of that endeavor, "It was all crooked. It was kind of difficult for a thirteen-year-old. At least I made it, but my mom straightened it out." That quilt has gone missing, and she says they're still searching for it. "Since we weren't so into quilting then, my mom gave it to my brother. He doesn't recall what he did with it."

It was not the original intent of Gee's Bend quilters to create art. "They were practical quilts, not made for decorating or show. They used to hang them out on the lines outside, and people got a chance to see different ones," she says. Many were heavy, necessary to fight off the cold of winter in houses that did not have insulation.

Arnett's arrival was met with some skepticism, given that he wasn't the first to show an interest in the quilts. "So many people had been in and out of Gee's

STRIPS | Loretta Bennett | 2005 | 95" x 76" | Corduroy, velveteen | Machine pieced, hand quilted | "My quilts are a window into my past," Loretta says. "They are like my family, all shapes and sizes—much like our lives, imperfect but still a family." *Photograph by Pitkin Studios*

Loretta Bennett works on a quilt. *Photograph by Matt Arnett*

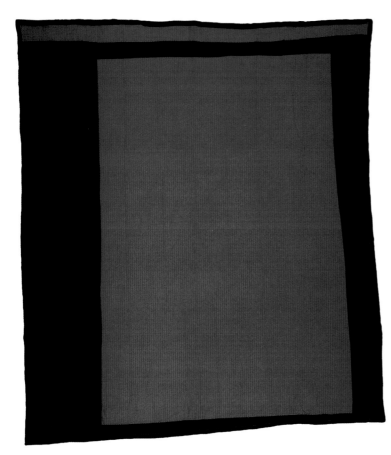

*Two-Sided Geometric Quilt*, reverse. *Photograph by Pitkin Studios*

Bend buying quilts," says Bennett. "They would buy the quilt and leave, and you didn't hear from them again."

Then came a show of the quilts, spearheaded by Arnett, which opened at the Museum of Fine Arts in Houston in 2002. Everything changed.

"That's when we were really discovered," says Bennett.

Though she didn't have a quilt in that first show, her mother did, as did several of her relatives. Many of the quilters took a bus from Alabama to Texas to see the exhibit.

"It was a mind-blowing experience. We couldn't believe it, even though we saw it. That whole week we were like, 'Wow we can't believe this, this is a dream, when are we going to wake up?'"

Bennett has lived in and out of Gee's Bend over the years. While she lived in Germany, she worked on traditional patterns—another Flower Garden, baby quilts, and a Double Wedding Ring quilt that took her three years to complete by hand, with her mother and grandmother doing the quilting when she moved back. Now, like the others, she makes quilts that feature geometric patterns that, on first glance, appear deceptively simple.

"Looking at the older quilts, I didn't see the art at first," she admits. "I had to stop and study and look to see how they put it together. I think using what they had at that time, that was the beauty of it—it was so simple and plain and yet beautiful."

Bill Arnett and his sons, who work with him, helped her to see the art. "When they were looking at them, they made us see what we couldn't see. There's a quote I like by the poet Edgar Degas who wrote that, 'Art is not what you see, but what you make others see.' That's how I feel about the Arnetts—it wasn't what I saw, it was what our quilts made other people see."

The fame that came with discovery brought a number of great changes to Gee's Bend.

"For the community I would have to say that the fame really got more women back into quilting. And with Arnett doing a book about us, we got a history lesson from it. A lot of the information they recorded in there, even though I grew up there, people had stopped talking about it. Another

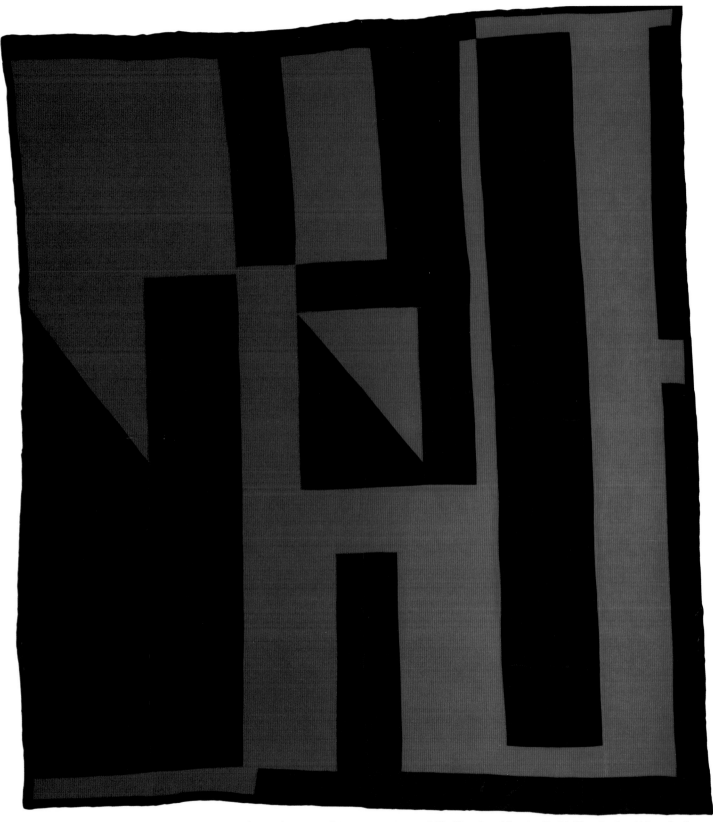

**TWO-SIDED GEOMETRIC QUILT** | **Loretta Bennett** | **2003** | **66" x 59"** | **Corduroy, velveteen** | **Machine pieced, hand quilted** | "There is a long history of quilt making in my family handed down from my great-great grandmother, to my great-grandmother, to my grandmother, my mother and aunties, and now me and my cousins. In the beginning, our quilts were made to keep our families warm, and today they keep our families warm in their hearts," says Loretta Bennett. *Photograph by Pitkin Studios*

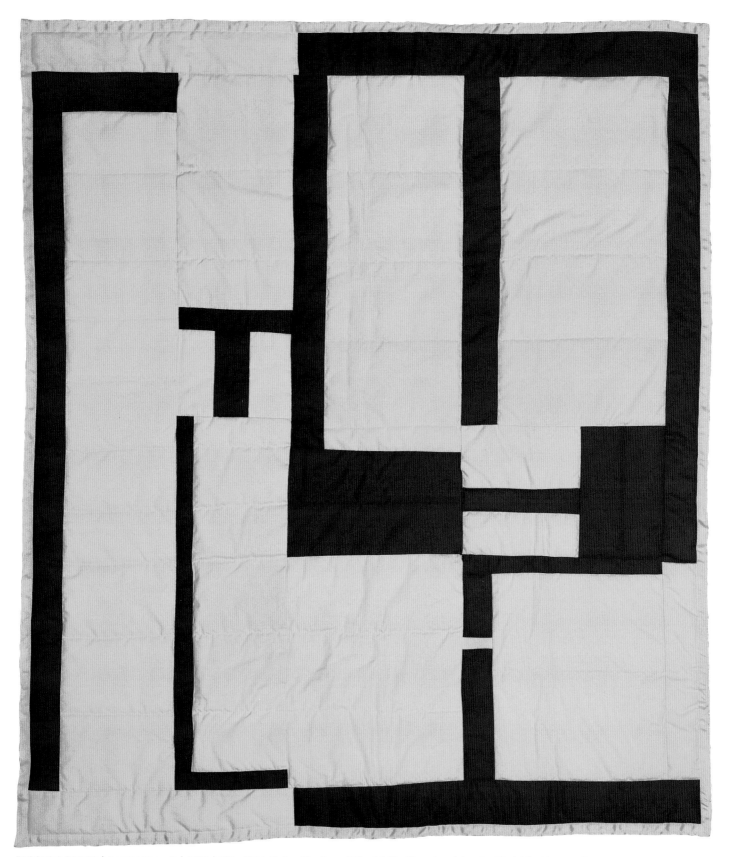

**BLOCKS & STRIPS** | **Loretta Bennett** | **2006** | **69" x 61"** | **Cotton blend, wool blend** | **Machine pieced, hand quilted** | Looking at earlier quilts by older quilters in the community, Loretta didn't see the art at first. "I had to stop and study and look at it and see how they put it together," she says. "I think using what they had at that time, that was the beauty of it—it was so simple and plain and yet beautiful." *Photograph by Pitkin Studios*

Loretta Bennett works on a quilt while Nettie Young, who at ninety-two is Gee's Bend's oldest living quilter, observes. *Photograph by Matt Arnett*

Loretta Bennett hand quilts her machine-pieced quilts. *Photograph by Matt Arnett*

thing, the ferry came back. Now they have an up-and-running ferry that only takes twenty minutes to get to town to buy food and clothing and get to a doctor."

Independence and access to new fabric also came to the quilters. "A lot of the ladies got a chance to do some work to their houses and buy more material. Some like to buy new material, which they weren't able to afford before because some of them were on a fixed income."

For Bennett, personally, she's had to try to adjust to the recognition. "I can't get used to when there's cameras around. I'm shy. When it comes to cameras and talking to a big panel of people, that's got to be one of the biggest changes. Every time I think about that—I know how stars feel when they hold up their hand."

Though the quilters have unique styles, their collected body of work is easily recognizable. "It's trickier than it looks,

but it's easy I guess because I've been doing it all my life," says Bennett. "I do like patterns, but lately I've just been free with it. I don't like trying to make things line up together."

She works in her home, sometimes sewing at the kitchen table, sometimes laying pieces out on the end of her bed. She sold her couch so she could have more space to work in her living room.

Sometimes she uses new fabric but says, "I like to use old clothes—old jeans and corduroy cotton shirts and dresses. I like to just cut them up. I use material I find at the thrift store—there seems to be stronger fabric, more heavy duty. I like making them from jeans because they're heavier and more durable, and growing up in a house that was not well insulated I liked something that was warm all the time. My husband jokes with me, 'If you're making these to hang on the wall, I don't know if the wall's going to be able to hold them.'"

**ADVICE FROM** *Loretta Bennett*

I think women are so defined by rules, and everything has to be so just right and perfect. Don't worry about being so restricted by rules and straight lines and worried about how your stitches look. That stops a lot of people. I don't like my stitches to be too small. Try to go freestyle and see what you come up with. I like to put on some music—if that's what gets you going. Sometimes I need total quiet. I like all kinds—jazz, hip-hop.

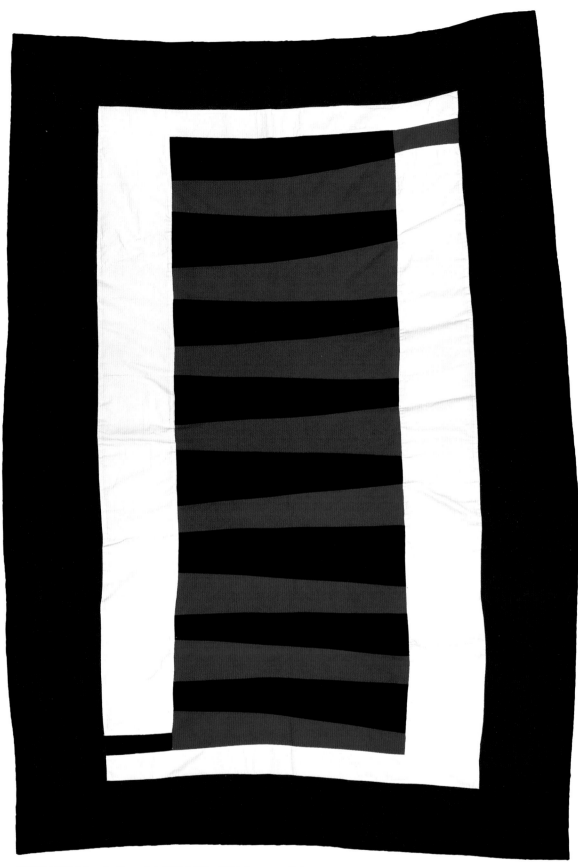

**MEDALLION** | **Loretta Bennett** | **2005** | **85" x 61"** | **Cotton, twill** | **Machine pieced, hand quilted** | It used to be when Loretta told people where she was from, no one had heard of her hometown. Then quilts put Gee's Bend on the map. "Now when you say Gee's Bend, everybody knows where it's at," she says. *Photograph by Pitkin Studios*

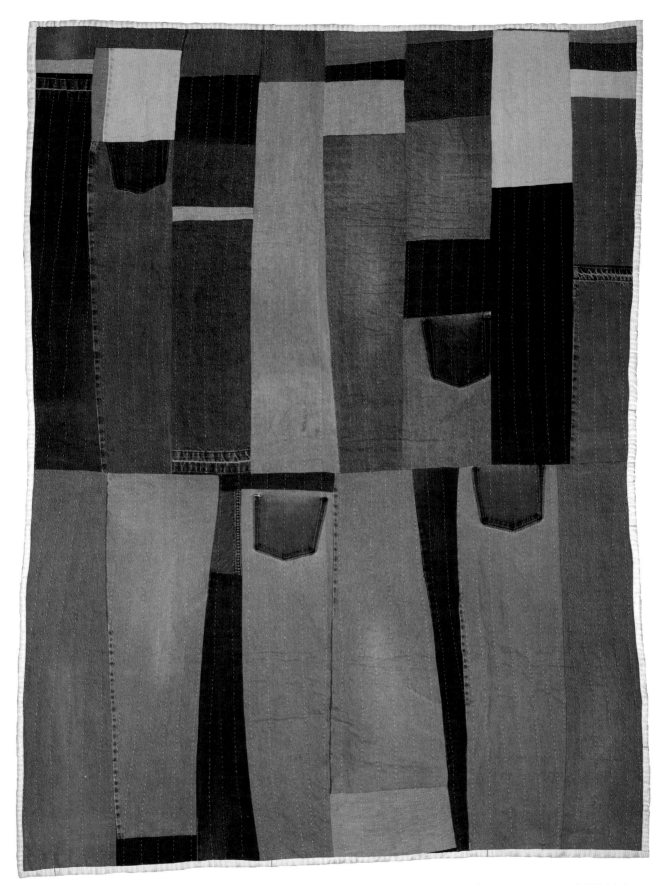

**WORK-CLOTHES STRIPS** | Loretta Bennett | 2003 | 79" x 60" | **Denim** | **Machine pieced, hand quilted** | Loretta often uses recycled fabric in her quilts. "I do use new fabrics," she says, "but I also like to use old jeans, corduroys, cotton shirts, and dresses." *Photograph by Pitkin Studios*

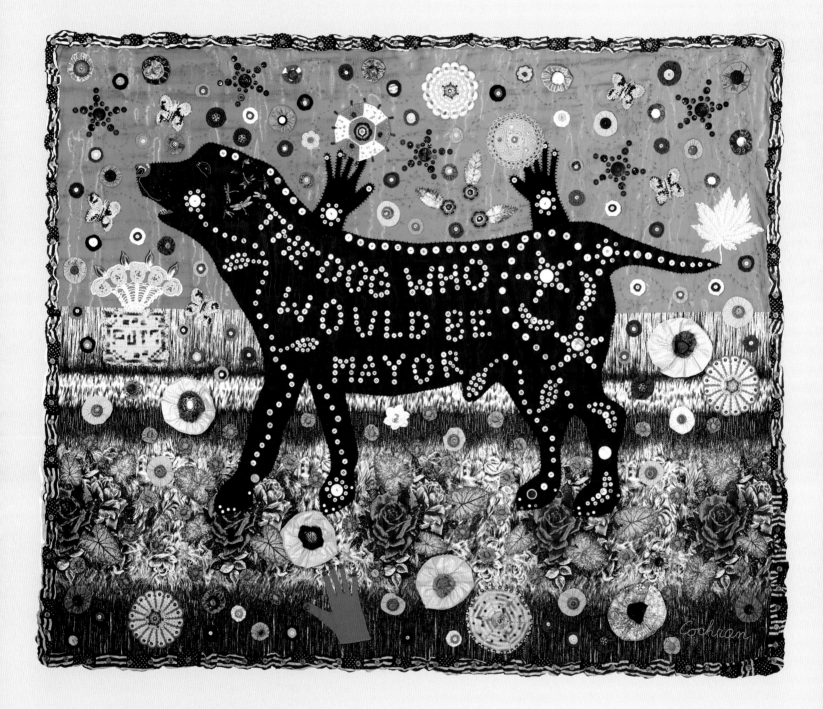

# Jane Burch Cochran

JANE BURCH COCHRAN'S QUILTS ARE, in the very best sense of the word, *busy*. The Kentucky artist loads her work with imagery and heavy embellishment, visiting and revisiting certain themes: food, dogs, race. And nearly all of her quilts feature old gloves selected from a collection that is ever growing, contributed to by friends and fans.

Patricia Malarcher, editor of *Surface Design Journal*, nailed Cochran's distinctive style when she wrote that the artist's imagery is "reminiscent of Eudora Welty's ability to see the strange in the familiar, or of Flannery O'Connor's sense of the spiritual in the commonplace."

Cochran began her artistic life in childhood, painting watercolors beside her grandmother, who took up the medium late in life. She kept along that path, taking art classes in college. In her thirties, she began the transition to art quilts.

"I started doing small fiber collages in about 1978," she recalls. "They had a very Native American influence. I would do beading on top of a Xerox of Native American–like work and frame these with painted canvas and more beading. I didn't call those quilts, but the words *fiber collage* didn't really mean anything to people."

Preparing for a show in 1985 that was to feature her paintings and some small beaded pieces, Cochran decided she wanted to create a real showstopper. "It was called *Crazy Quilt for a Half-Breed*. It had all these notions—working on it, I would fancy myself a Victorian woman connected to a Native American man. My husband and I used to camp out West in tepees in the mountains for ten days at a time. I got very into Indian beadwork."

LEGACY | Jane Burch Cochran | 2007 | 64" x 77" | Fabric, beads, buttons, fabric yo-yos, crocheted potholders and other crocheted items, gloves, fabric leaves, crochet-covered bottle caps | Hand appliquéd, hand embellished, hand quilted | Jane's black lab, Junior, was the mayor of Rabbit Hash, Kentucky, where she lives. "We really don't need a mayor, but we needed money to fix the 175-year-old general store, so we had an election where votes cost one dollar each," says Jane. Junior, who passed away in 2008, was the town's second dog mayor. "I wanted to do a quilt about him but I also wanted the quilt to convey some more unexplained message if you did not know the true story," she adds. *Photograph courtesy of the artist*

Her work has never been conventional, though she thinks viewers' perception of it might have changed, perhaps because these days a lot more quilt artists create nontraditional work. "My stuff was kind of weird back then. Now it looks more conservative," she says. But being the oddball didn't hurt her when it came to getting into shows early on. "If you're the odd man out they say, 'Let's throw her in.'"

She describes her work as "wacky patchwork" and admits she's hardly a stickler for a plan. "I don't like to measure out. I like not knowing what's going to happen. I pin strips together, and I don't use rotary cutters. I either rip or use scissors. I don't follow many quilt rules because I don't know how and it's too strict for me."

She hand-appliqués images on a background, which is often painted canvas. Bugle beads are a favorite, and her pieces literally shine with thousands of these tubular

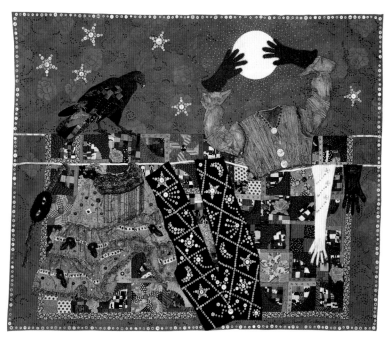

LIFE LINE | Jane Burch Cochran | 1994 | 62" x 82" | **Various fabrics and old clothing treated with paint and colored pencil, beads, buttons | Machine pieced, hand appliquéd, hand embellished** | "In rural Kentucky, you still see a few clotheslines," says Jane. "I love to see the clothes waving in the breeze. They tell a story about a family. *Life Line* is my self-portrait on a clothesline." *Collection of Dorthy Gleser. Photograph by Bronze Photography.*

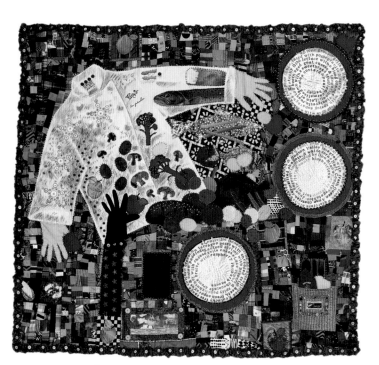

BY THEIR HANDS | Jane Burch Cochran | 1998 | 55" x 60" | This quilt was created for an invitational show called Women of Taste, a collaboration celebrating quilt artists and chefs. *By Their Hands* was made to honor Kathy Cary. *Collection of Kathy Cary. Photograph courtesy of the artist.*

bits of colored glass. When it's time to put layers together, she also breaks tradition.

"It is traditional in that it's a sandwich," she says. "But I don't do traditional quilting with quilting thread. I'm not a very precise sewer, even after all these years. I've never machine-quilted a whole quilt. I use big, random stitches with embroidery thread. I also tie through the batting and backing when I sew the buttons on using full-strength embroidery thread."

Her use of gloves—such a signature that she might consider legally hyphenating her last name to Glove-Cochran—was born of an idea she originally rejected. "It actually came from a good friend of mine. She'd found a box of cotton work gloves and said, 'Couldn't you use these in a quilt?' I said no, but the idea was put in my mind."

Later, when she was working on a piece in which she wanted to include one of her late grandmother's paintbrushes, she decided to use a glove to represent a hand holding the brush. "It started from there. Now people

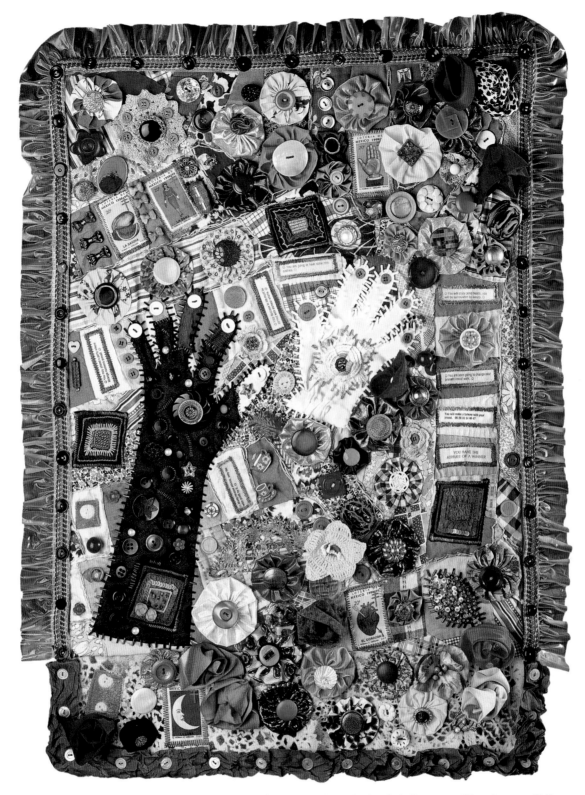

**UNSPOKEN BOND | Jane Cochran | 2000 | 30" x 23" | Various fabrics, paint, beads, buttons, a small found crazy quilt, Xerox transfers of Chinese fortunes and Mexican stamps, gloves, plastic ruffle from shower curtain | Machine and hand appliquéd, hand embellished |** Jane says, "I was inspired by an old quilt piece I found at a flea market that needed some attention. I used it as the background and covered it with yo-yo flowers, Xeroxed fortunes and Mexican lotto cards, plus beads, buttons, etc. The large and small gloves and the title refer to many children who are taken care of by nannies of different races. Although I did not have this experience, I know it is a very bonding and loving one to many who have." *Collection of Fidelity Investments, Covington, KY. Photograph by Bronze Photography.*

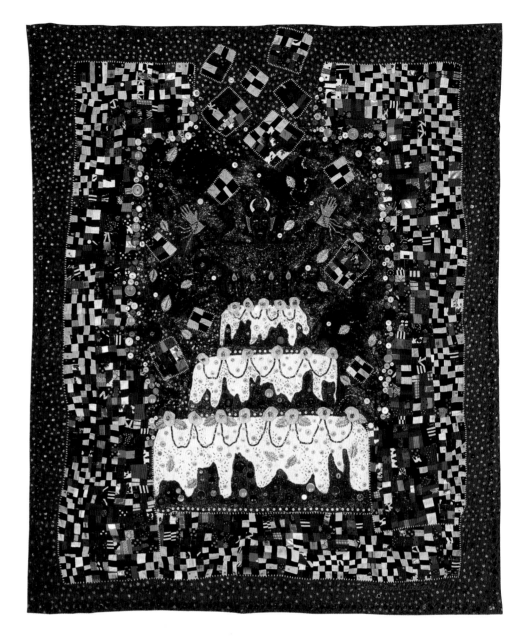

**SURPRISE PARTY | Jane Burch Cochran | 1991 | 72" x 64" | Fabric, beads, buttons, paint, fabric leaves, Mylar flowers | Machine pieced, hand appliquéd, hand embellished and beaded |** Jane Cochran says, "My favorite dessert is cake of any kind. The *Surprise Party* cake is a birthday cake with a devil jumping out of the center instead of a bikini-clad woman. The devil reminds us that life is full of surprises. This devil is more playful than evil. His appearance is taken from a carved Mexican devil with green ears I own and love." *Collection of George R. Stroemple. Photograph by Bronze Photography.*

give me gloves constantly. I have a huge box of them—you would not believe. I did reach a point where I said, 'I can either quit using the gloves or I can push them.' I chose the latter and to keep being creative in ways I use them. People think of me so much as using the glove. I do use it, but I don't think I *need* to use it. It just sort of pops in there."

Cochran's food-themed quilts might, on the surface, appear merely whimsical. But deep meaning lurks not far below. For example, take her first food quilt.

"The first food piece I did was the one with the devil jumping out of the cake. I just thought of a big birthday cake and then instead of a naked lady the devil was going to jump out. I'd been to Mexico and had gotten a nativity scene that had the devil included, because evil is always present with the good. Later, I thought, *Oh my God—that's a self-portrait because inside you're always struggling with your demons.*"

Working on that piece proved so much fun she decided to do another food quilt. "Behind that one is the idea that

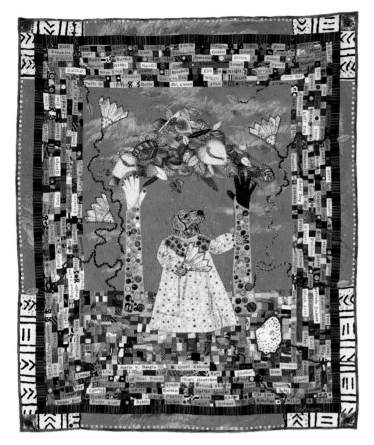

**LOOKING FOR GOD** | Jane Burch Cochran | 1996 | 74" x 64" | "I wanted to do a quilt about my first black lab, Barker, who had been my studio companion for thirteen years," says Jane. "I had sketched, pondered, and dreamed on this for several years. What finally came together was this quilt, which is about my yellow lab, Belle, because it was easier to bead a yellow dog head. I loved making this quilt, and it hangs in my living room as one of the three quilts in my personal forever collection. *Photograph courtesy of the artist*

people accept ethnic food before they accept different races. You think food is such a lighthearted thing, but some of the heavier quilts I've done have been about food. I did another one called *Last Suppers* about prisoners' last meal requests before they're executed. It was a very hard piece to do."

As for the regular occurrence of dogs, that series came from a need to lighten things up a bit. "I had just done a quilt for a show about the children who had been killed in the Oklahoma bombing. I didn't think as I was working on it that it was affecting me as much as it was. After that I needed to do something for fun."

Because her work is so bright, Cochran knows she runs the risk of being misconstrued. "I feel I walk the line between cute and hopefully not cute. I try to not be cute. I use a lot of other materials besides just cotton. I want a variety of texture and to keep it from being cute."

Though she has spent her career mostly deadline driven, lately she's moved away from that pressure. "I needed some time to kind of play," she says. "I think when you're on a deadline you get more done. And I can work under pressure. But my hands were wearing out. I needed a break, but I don't want to take a break. I always have these ideas flowing. My art has always been my place I feel free to do whatever I want, even if it's on a deadline. In my generation you grew up to follow the rules and be a good girl. Art was always my escape."

ADVICE FROM *Jane Burch Cochran*

When having a show you want at least one showstopper if you're just starting off—something to knock their socks off. To me, in quilts, it often has to do with size. Also, I believe in finishing things or forging ahead. I think you can't look for outside people to say you're okay to keep you going. I've been lucky to have that happen, but it took a while. Some people quit too early and say it won't work. I fool with it until it does work. You have to just try hard.

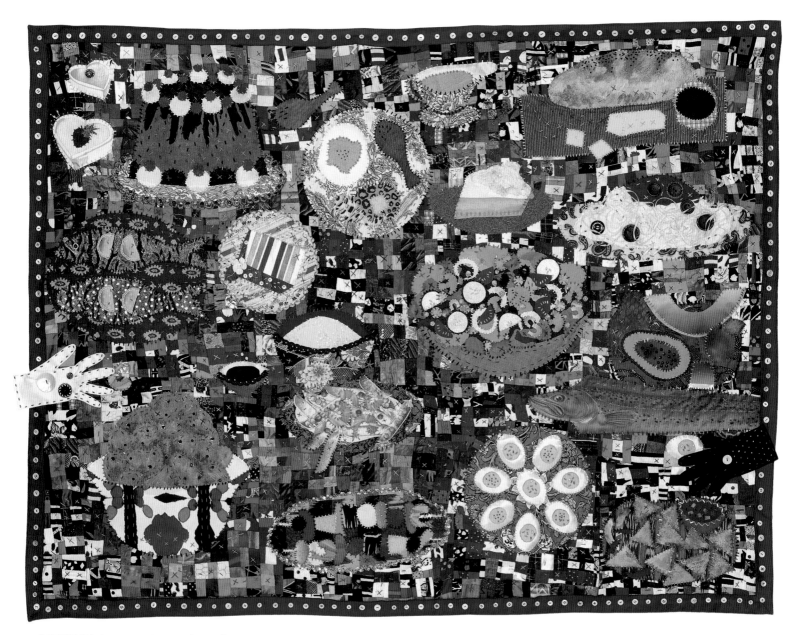

**POT LUCK | Jane Burch Cochran | 1993 | 85" x 68" |** *Pot Luck* is the fourth quilt in an ongoing series called *Food for Thought*. Jane says, "This quilt was inspired by the tradition of taking food to gatherings to share with the other guests. My hope is that we can learn to accept and respect other races and nationalities as easily as we accept and enjoy their traditional food." *Collection of Fidelity Investments, Covington, KY. Photograph courtesy of the artist.*

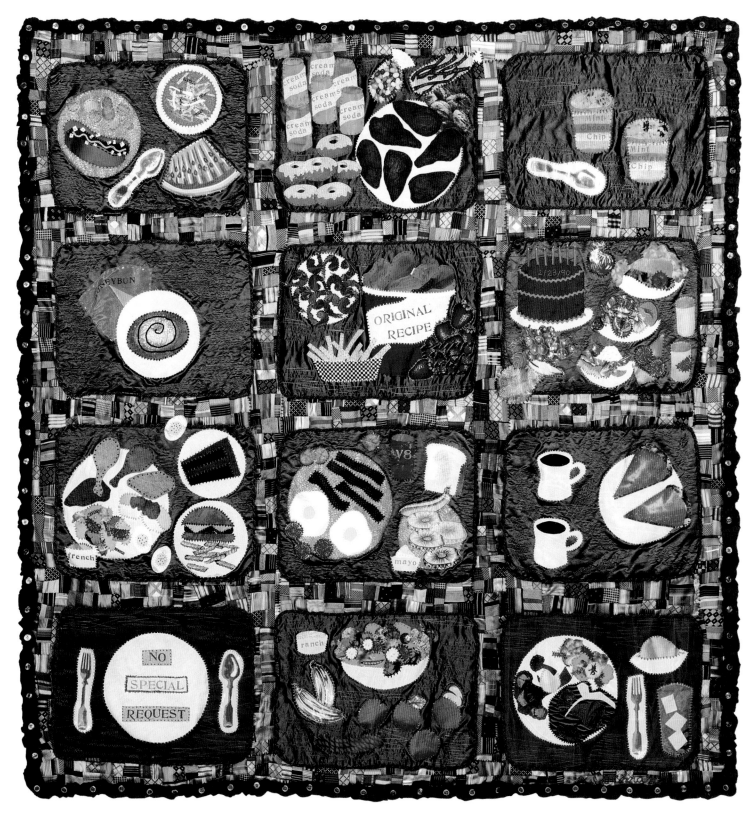

**LAST SUPPERS** | Jane Burch Cochran | 2007 | 69" x 66" | Various fabrics including necktie silks, silk taffeta, cottons, blends, and oilcloth; beads, buttons, paint | Machine pieced, hand appliquéd using beads, hand embellished, machine and hand quilted | In many prisons in the United States, a prisoner who is about to be executed can make a final meal request. *Last Suppers*, which features twelve selected meals, explores this strange and haunting ritual. *Photograph courtesy of the artist*

# Dominie Nash

ON A CHALKBOARD IN HER STUDIO, Dominie Nash keeps a quote attributed to the painter Philip Guston: "I go to my studio every day. Because one day I may go and the angel may be there. What if I don't go and the angel comes?"

Whether she's feeling inspired or not, Nash, like Guston, always shows up. "I save all my errands until the end of the day," she says. "I come in in the morning and work whether I accomplish anything or not—because of the angel. I think focus and persistence are really important; not just getting your name out there, but getting better in your art. Even if I'm just staring at the walls I go to my studio every weekday. And I spend every Saturday at home on the computer doing all the show entries. It takes a lot. But I don't say 'I'm not going in today.'"

Nash came to art "in a roundabout way," as she puts it. Originally planning to be a social worker, she decided while doing postgraduate work that she and social work just didn't click. "I was trying to find what I wanted to do. I was always knitting and sewing practical stuff since I was a teenager. I decided to try doing that more seriously."

So she joined a craft co-op and made pillows and children's clothing. In the process, she met weavers and, impressed with their work, took up the craft herself and stuck with it for many years. But when she set up her first studio away from home, she didn't bring her looms with her. Instead, she gave up weaving for good and focused on fabric printing and teaching herself quilting techniques, which

**STILLS FROM A LIFE 31** | **Dominie Nash** | **2008** | **54" x 54"** | **Cotton, silk organza** | **Machine appliqué and quilting** | Dominie says, "This is a 'self-portrait' made for an exhibit with that theme. It pictures places and things in my home that I see every day." *Photograph by Mark Gulezian/Quicksilver*

**STILLS FROM A LIFE 29** | **Dominie Nash** | **60" x 138"** | **2006** | **Cotton, silk organza** | **Machine appliqué and quilting** | Each March, Dominie travels to Europe to meet with a quilt art group in Cologne. She says, "This still life represents different views of a colorful tabletop arrangement in my friend Inge's home in Cologne." *Photograph by Mark Gulezian/Quicksilver*

Dominie works in a large, bright studio in an artists' co-op. "One of the best features is my 8x8-foot cutting/printing table," she says. *Photograph by Ori Sofer*

Like many artists, Dominie hangs on to leftovers from completed projects. "I always cut off and save the selvages of my dyed fabric, as I'm sure I will do something brilliant with them one day. In the meantime, they are preserved in these old canning jars." *Photograph by Ori Sofer*

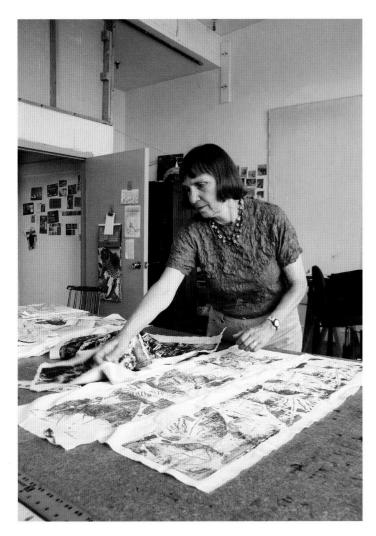

Dominie working at her design table in her studio. *Photograph by Ori Sofer*

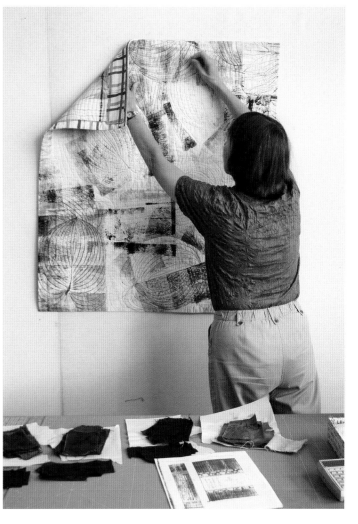

Dominie working at her design wall. *Photograph by Ori Sofer*

"My drawing/designing materials are organized (sort of) on the top of built-in cupboards, so they are always available—and collecting dust when I don't use them." *Photograph by Ori Sofer*

"finally evolved into the technique I use now, sort of an appliqué. I didn't want to make pieces fit together. That was too against my nature and my level of ability. What I do is collage work."

Nash works in series, sometimes using a preconceived pattern, sometimes working intuitively. She'll begin with her favorite part of the process—dyeing and printing a bunch of fabric so she has an ample palette. Then she moves to her wall for composition.

"For my still-life pieces I have a very definite plan. I haven't chosen the fabrics or colors, but I make sort of a full-sized pattern so I know where the shapes are. Then I put that pattern up and fill in pieces with color, and they overlap. With the *Big Leaf* series, I don't have as much of a plan—sometimes I just put hunks of fabric up."

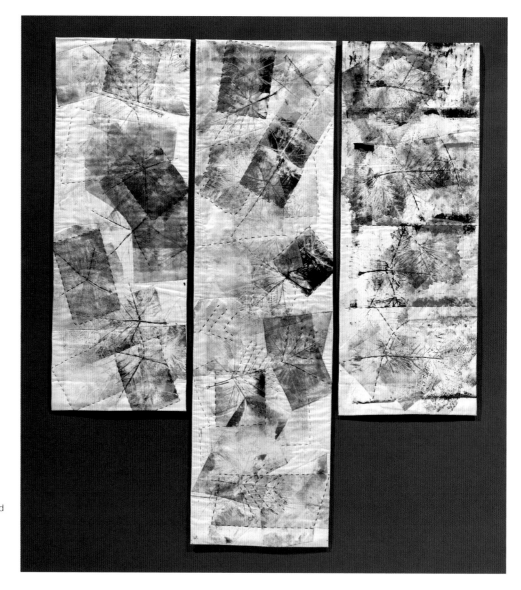

BIG LEAF 2 | Dominie Nash | 2006 | 57" x 48" | Cotton, silk organza | Whole cloth; appliqué, hand embroidery | Dominie says, "The fabric printed with large sycamore leaves was used in this triptych, which ended up looking like a kimono, although I hadn't planned it that way." *Photograph by Mark Gulezian/Quicksilver*

Once Nash has a good idea of composition, she moves the work back to the design table and bastes the pieces together, sometimes rearranging a bit as she goes. Then she sews around all the pieces with her machine, leaving the edges raw. When that stage is completed, the top is returned to the wall, at which point the artist decides where to place pieces of organza, which is featured in nearly all of her work. When the organza is in place, it, too, must be basted and then sewn. "The process is very tedious," says Nash. "It's the part I like least."

At that point, if she thinks her work still needs a bit more, she'll embellish with crayons and pastels. "Then it's ready to be quilted," she says. "So I sit at the machine and within each shape decide how I want to quilt it. Whatever the fabric and shape require. Then it's done except the facing. A lot

of people who make quilts do a binding. I don't like to do that; I think it stops the design. It's a traditional quilt thing. There's no reason to do it on an art quilt."

Community is essential to her growth. "The quilt groups I belong to are very important to me," she says. "There's one in DC, one that meets once a year in New York, and one in Europe—I go over twice a year for meetings. In the group I attend regularly [the DC group] everyone's really professional, but we're still a little too polite when we do critiques."

Nash attributes this over-politeness to a "hangover" from the days of quilting bees when women came together for, among other things, emotional support. But with art quilts, she and her peers want to move beyond that. "So we have hired people to come and give us critiques," she

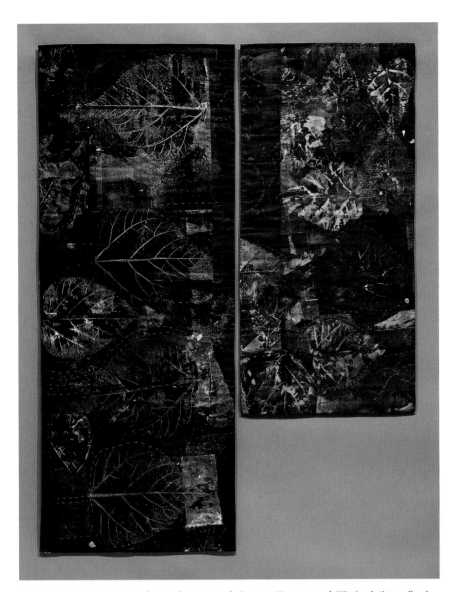

says. "Our most recent critic is a curator and a writer. He's juried a lot of shows, and he's friendly toward textiles. He didn't know a lot of technical stuff, but we didn't want that. He treated it like an art form. His background is fine arts. He didn't care how something was made. He just looked at the work."

These days, Nash exhibits her work regularly, and she's well known and respected. But she remembers the early days, working for recognition. "I've had the usual experience where I thought, *This is the most wonderful thing in the world and they didn't take it*, and I'd think, *How can this happen?* and I cried. I don't cry anymore."

She attributes some of her success to persistence. "For a while I entered everything that came along. If there was an opportunity, I would take it. I'm not very good at person-to-person networking, but I'd send things out. There are a few people I know who do one or two pieces a year that are real masterpieces, but that's the exception."

**BIG LEAF 4 | Dominie Nash | 2006 | 55" x 41" | Cotton, silk organza | Whole cloth; appliqué, hand embroidery |** Dominie gathered catalpa leaves across the street from her studio, printing them with several types of discharge chemicals on several different black fabrics, resulting in a range of colors.
*Photograph by Mark Gulezian/Quicksilver*

ADVICE FROM *Dominie Nash*

Take yourself seriously. I think a lot of women think they can do this after everything else is done. I don't think you're going to get very far in your work if you don't say, "I need this time and this space." A lot of people work out of a tiny space, such as a dining table, that's fine. But don't let people interrupt you. Even when I was working at home I set my business hours. I don't go out and fool around or do other things during that time unless it's really, really important. Also, you can work through a lot of ideas in a series to find out what your style is. You can't do that if you do one of this and one of that.

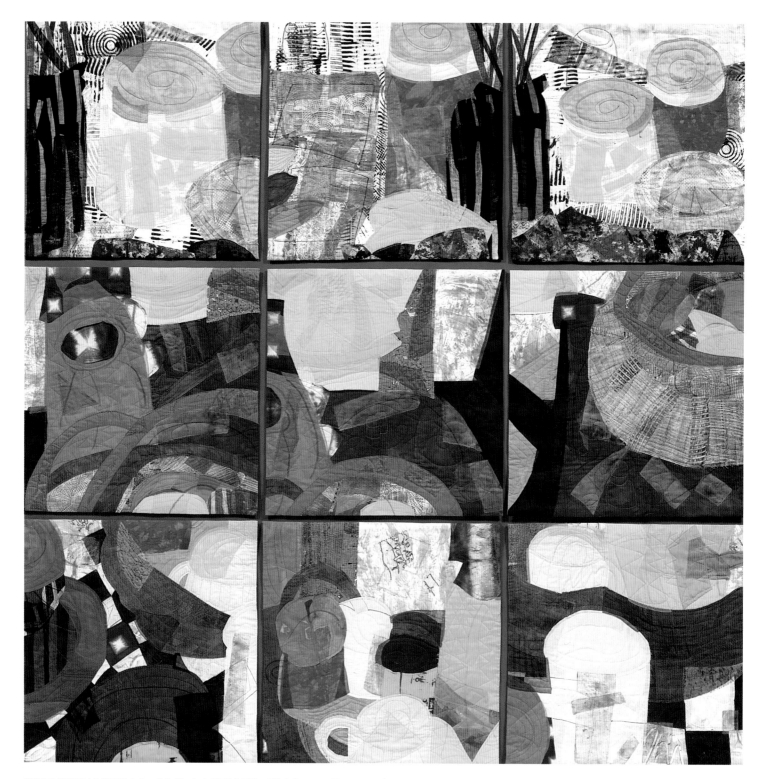

**STILLS FROM A LIFE 27** | **Dominie Nash** | **2006** | **82" x 82"** | **Cotton, silk organza** | **Machine appliqué and quilting** | Taking inspiration from her regular surroundings for this piece, Dominie says, "This is a depiction of my studio, with three different views of three areas where I work every day." *Photograph by Mark Gulezian/Quicksilver*

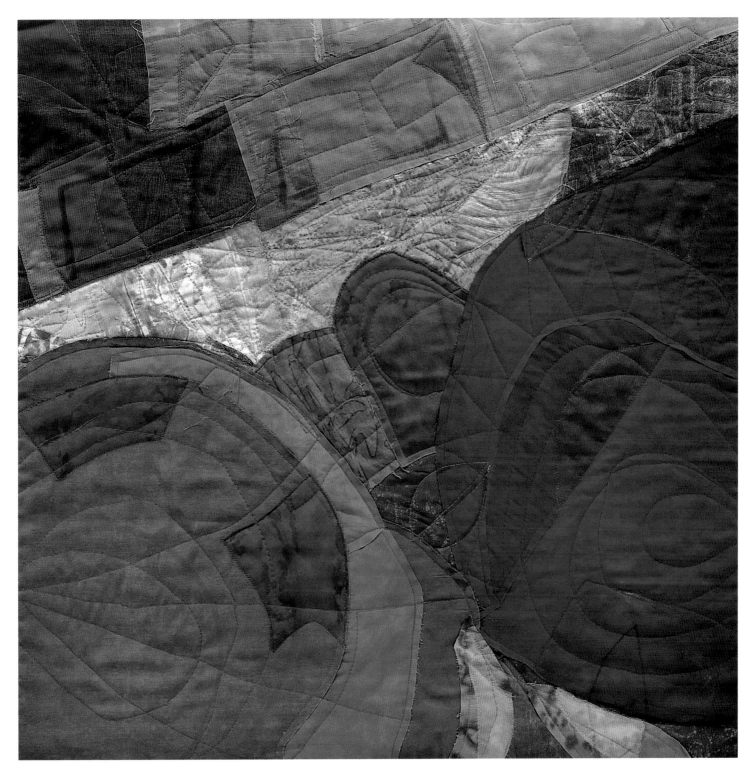

**STILLS FROM A LIFE 33** | **Dominie Nash** | **2008** | **27" x 27"** | **Cotton, silk organza** | **Machine appliqué and quilting** | *Stills from a Life 33* features upside-down garden vessels to form an abstract composition. *Photograph by Mark Gulezian/Quicksilver*

# Malka Dubrawsky

MALKA DUBRAWSKY IS A BIG FAN of process. The Texas resident began her life as an artist as a college student majoring in studio art and immersing herself in printmaking.

"We made lithographs, and I really liked that process. We'd work on these big, Bavarian limestone blocks, and there were all these things you had to do to get the image to the point where you could print it. I liked all the unexpected things that happened."

When she graduated, she no longer had access to the huge studio and equipment she would need to continue that sort of work. Instead, she turned to sewing. "I was always interested in sewing. My mom sewed begrudgingly. She would be the first to tell you she doesn't have the patience to teach."

So Dubrawsky bought a sewing machine at a garage sale and made a few things before deciding to try her hand at quilting. "It was a little quilt. I didn't think that much of it."

Then, she took an informal class in dyeing fabric, and things changed. "The processes—shibori resist, and wax resist batik—and the ability to combine the processes reminded me of making prints. All this stuff was happening in one place. I couldn't control it, but I could respond to it. I really liked surface design and manipulating a whole piece of fabric. But I also liked cutting things up and putting them back together."

**LEFT TO WRITE, front (top) and back (bottom) | Malka Dubrawsky | 1996 | 41" x 33" | Hand-dyed and pattered cotton and silk fabrics | Machine pieced, improvisationally; hand and machine appliquéd and quilted** | Malka describes *Left to Write* as a smorgasbord of techniques. "It combines shibori processes such as arashi and itajime with improvisational piecing and appliqué," she says. "It really was a wonderful opportunity to experiment." *Photograph by Ori Sofer*

**KENTE, detail | Malka Dubrawsky | 2002 | 29" x 35" | Hand-dyed and batiked cotton fabrics | Machine pieced and hand quilted**

Malka says, "A lot of my inspiration comes from other textiles, particularly African textiles. *Kente* is my interpretation of traditional kente cloth. It began with the cotton fabric that I patterned with wax resist and then was cut up and pieced to imply a woven surface." *Photograph by Ori Sofer*

Next, she took a basic quilt class. "When you take a traditional class they're so uptight about getting points right. A lot of the women in the class were concerned whether things matched. My attitude is everything goes together. I wanted to just put it together and see what happened. I started doing that and using my own dyed fabrics. I never made a traditional quilt again."

While a lot of quilt artists make pieces designed to be hung, Dubrawsky has a different perspective. "I make a lot of functional items. I like when art can really function in life to where it's not just hung up on the walls, where a person can touch it and interact with it. A lot of the goals of the art-quilt movement have been to make quilts into fine art. I tried for a while. It felt empty."

In addition to home-schooling her three kids, Dubrawsky works every day on her art, giving some time to dyeing and some to sewing. She also spends a lot of time marketing,

using her Flickr account, her blog, and her Etsy.com shop to get the word out about her work.

"The nice thing about the online community is that it's very positive," she says. "I think if people don't like what you do they don't say anything. It's the opposite of what I saw in art school. It's more competitive in art school. In the online community it's not like there's a limited amount of love. I've found it to be very positive and supportive, and it fits into people's lives. You can go into their world for your limited amount of time. You get all the good stuff but not all the stuff about how their car didn't start this morning and their cat threw up."

"Flickr has been a great promotional site for me. I've had numerous people contact me. On my profile page I mention I have a store. I try not to do too much overt marketing. Sometimes I see someone else's page and every other sentence is, 'I just added this to my store.' I try to keep it

lighthearted. I'm really happy with Etsy. I think there are some basic problems with both Etsy and the DIY movement that need to be addressed, but I'm not sure what the answer is."

One problem is that she finds she must sell her work basically at cost. "People making handmade things aren't competing against each other, they're competing against big retail stores like Target where you can go in and buy a bed quilt for a hundred bucks, even though it's a completely different thing. You don't get an individual item. You're not investing in someone's personal creativity. But I feel like sometimes the customers who shop at Etsy want it at the Target price."

She tries to let go of worrying about what people want. "When I was in school, one professor said, 'Just so you know, when you get out of school no one's going to care what you make anymore.' I think he meant that being in school is a great opportunity, a captive audience, you should value it and take advantage of it. I also think it means your art can't be about what other people want you to make, it has to be about what you think is important. It has to be a very individual experience because in this field, you're on your own."

Being online so much offers her an added benefit—she finds inspiration in the images she sees on Flickr. "I remember feeling like my eyes were hungry to see something new that would stimulate some new idea. I'm not a Luddite who says we should just go back to the rock. I love having access to lots of images."

Dubrawsky creates geometric-based pieces, sometimes with repeating patterns. "I've never been one to make representational images. My work reflects the same thing that I liked in art school—lines and shape and texture. I've never been an image-maker. My husband says I make associations in my head about the way patterns and shapes fit together. I play with patterns, colors, and textures, I like the idea of images coming forward and receding. I'll say, 'Isn't it cool how this comes in?' and he says, 'You're the only one who sees that.'"

A fan of African and Indian textiles, she also has come around to the idea of incorporating commercial fabric into her work. "For a long time I looked down my nose at including commercial fabric. I was into surface fabric techniques. Now I'm a lot more interested in commercial fabric. I have several quilts where I've over-dyed commercial fabric or taken parts out with bleach. I'm a lot more interested in mixing the two worlds, bringing together things made for mass consumption with things I make myself."

To keep things interesting, Dubrawsky keeps multiple projects going at the same time. "If I have just one thing going, it puts too much weight on that one thing. It's important to have multiple projects. If I have started something from way back, I will eventually finish it—I never get rid of anything. My husband asks if there is a piece too small for me not to keep. Really, no. I'll keep teeny tiny pieces. When I decide to go back and finish a quilt I'll think, *You know that little piece . . . that would've gone great here.*"

**ADVICE FROM** *Malka Dubrawsky*

I think people should be freer with color. I just wouldn't stress about it. I wouldn't worry that things won't go together. I don't know what "go together" means. Two kids in high school go together. Just be freer and don't sweat how you put things together and what you put together. It should be a liberating experience. It shouldn't feel like something you have to worry about.

**RACHEL'S OCEAN** | **Malka Dubrawsky** | **2001** | **50" x 90"** | **Hand-dyed and commercial cottons and linens** | **Machine pieced, improvisationally; machine quilted** | This bed-sized quilt—used for that purpose—is an improvisational take on a traditional quilt pattern called Ocean Waves. *Photograph by Ori Sofer*

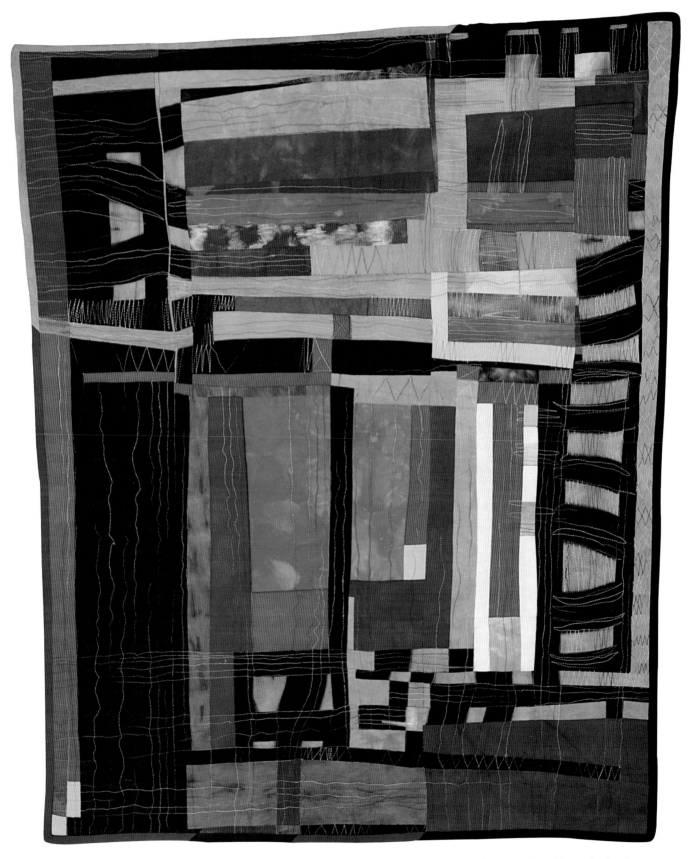

**UNTITLED | Malka Dubrawsky | 1998 | 31" x 38" | Hand-dyed, discharged, and over-dyed cottons | Machine pieced, improvisationally; machine quilted |** "This wall quilt was one of my first forays into a shibori technique that I still use today," says Malka. The technique, itajime, uses clamped shapes to create patterning on fabric. *Photograph by Ori Sofer*

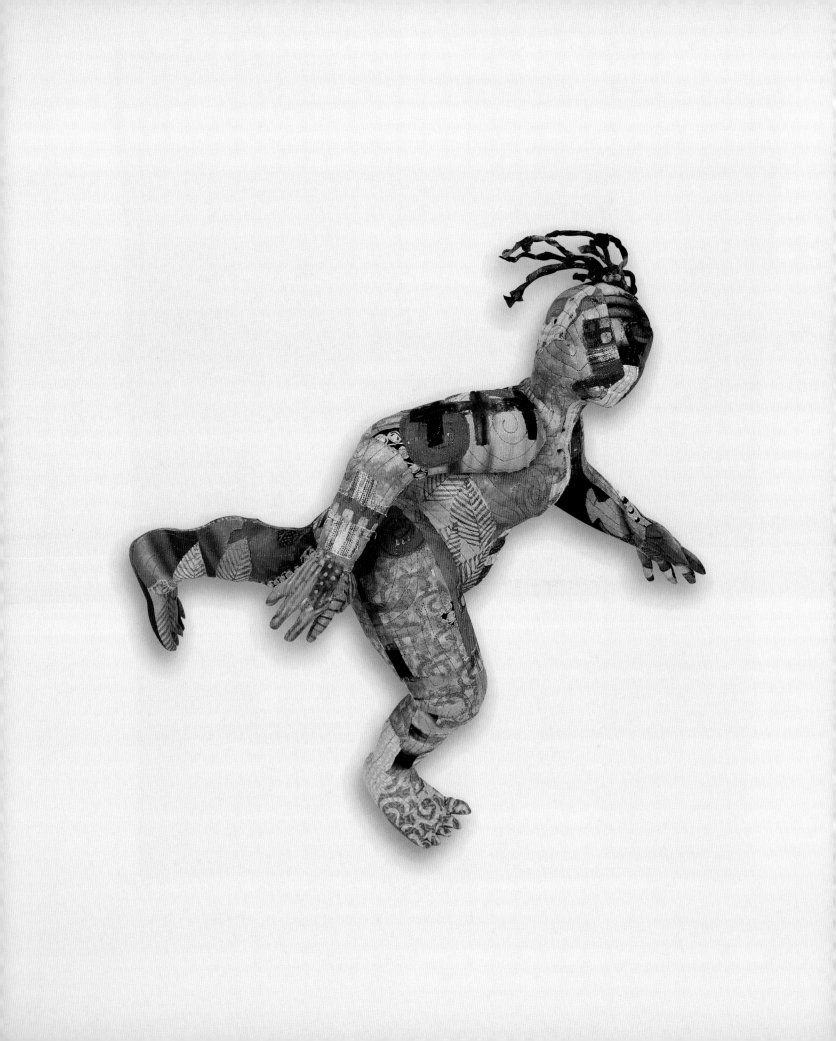

# Susan Else

SUSAN ELSE WAS POSITIVE, from a very early age, that she would avoid the life of an artist. "I grew up in a family of artists. My dad was a painter, and my mom was a sculptor. I was dead certain I was not going to be an artist. I'd go to openings as a child, and they'd say 'Susie, are you going to be an artist?' and I'd say 'NO.' I had always planned to be a writer."

Still, the California artist was interested in fiber arts as a craft—"I didn't think of it as an art," she says—and this eventually led her to change her mind about following in her parents' footsteps or, as she jokingly puts it, giving in to "the family curse."

Else began weaving as a young woman and pursued this path seriously for a decade. "I did a lot of weaving and spinning. It was all pretty much functional. Toward the end I started doing wall hangings." But she eventually grew bored with the loom's grid and the fact that "the right-angle geometry is hard to get away from."

She started taking quilting classes when she was expecting her first child, but initially she was interested only in making bed quilts and pillows. "I had no idea I was going to go into the art side of it." In fact, she only made one bed quilt because, she says, "It took me forever to finish anything. For many years I'd only do quilting during the class."

Then, in the mid-nineties, she took time off from work and decided she wanted to get serious about the quilting, beginning with some wall hangings. She quickly

GAINING | Susan Else | 2008 | 21" x 21" x 11" | Commercial and hand-treated cloth, thread, and yarn over an armature of fiberfill, wire, and polystyrene foam | Machine reverse appliqué, machine sewing and quilting; needle-sculpting and hand assembly of 3-D elements | This piece is part of a series of full-bodied people engaged in active pursuits. A metal mount in the base extends from the foot up through the leg.
*Photograph by Marty McGillivray*

**NOTHING TO FEAR** | Susan Else | 2008 | 49" x 30" x 27" |
**Commercial and hand-treated cloth over commercial
plastic skeleton and polystyrene foam** | **Machine
reverse applique, machine quilting; surface attached
to armature with hand stitches** | "When I was a museum
registrar, I had the opportunity to work with a wonderful
collection of Day of the Dead figures," Susan says. "Although
this is not a Day of the Dead piece, I've always wanted to
make a skeleton of my own. I bought a commercial plastic
skeleton and, over the course of a year, covered it with quilted,
reverse-appliquéd fabric. I create ambiguity in my work by
merging contradictory ideas: life/death, fear/festivity, reason/
terror, flowers/bones, conversation/silence." *Photograph by
Marty McGillivray*

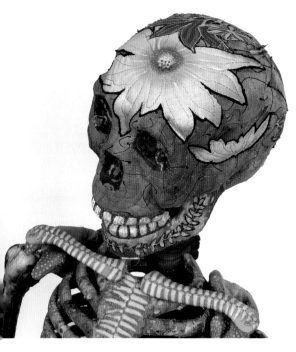

*Nothing to Fear*, detail. *Photograph by Marty McGillivray*

Susan Else working in her studio. *Photograph by Marty McGillivray*

"For a long time, my pieces extended out from the wall," says Else. "Gradually, over the last ten years, they have climbed off the wall entirely."

Her work is always wry, is often humorous, and addresses the ambiguity we encounter every day. For example, *Lifetime* features a curvaceous female figure, primarily red, standing on a scale.

Else explains the story: "I was always a skinny person and then hit midlife and could not lose weight. I went to Weight Watchers, where when you reach your goal they call it 'Lifetime,' as in 'You've achieved your lifetime goal.' Paradoxically to stay at that goal you have to keep up with the plan and lifestyle it took to get there. You never quite get off that scale. So there it is, it's an experience out of my own reality. And yet the person is bright red, and I've painted all over her surface little circles, squares, numbers, and check marks. Because if you do one of these food plans then you get very involved in checking things off and keeping track of numbers. So she's surreal at one level and very grounded and routine at another level. I'm trying to make an ambiguous comment on something going on in our culture right now. But it's a cheerful piece. So there's a lot happening there. A lot of my work works on those multiple levels—the surface is intriguing and attractive, and then there's a certain ambiguity in the message."

There is a narrative and an edge to all of Else's sculptures, and this is intentional. "Because it can become cute at the drop of a hat, which is not what I want, I have to work very hard to maintain an edge so that my work says something significant. Working with cloth you run the risk of becoming too engaging—people associate it with warmth and comfort and stuffed animals. You can be seduced by the accessibility of the material."

Her inspiration comes from working. "Work generates more work," she says. "Working is the time when I find the best ideas and most creative ideas. Inspiration doesn't come from a mountaintop for me, it's tied up in the process of making art."

Else does as much work as she can on her machine. "I do machine reverse appliqué with invisible thread. The actual

got hired by P&B Textiles, joining a stable of quilters who make model quilts. "That was my Design 101. You had to turn around a particular quilt in a particular style in a short amount of time. There were a lot of parameters. It taught me how to cut to the chase, and it made me feel professional."

A few years later, she was inspired when a friend of hers started making cloth figures. "I said, 'Those aren't dolls, they're little sculptures.'" Her first foray into fabric sculptures involved sewing two profiles together. This was at the same time she was working on a flat art quilt to which she'd added some depth to the inner border. One day, she put the two together, and her little sculptures "looked like figures on a stage."

*Rapunzel Considers*, detail. *Photograph by Marty McGillivray*

**RAPUNZEL CONSIDERS | Susan Else | 2007 | 39" x 18" x 29" |**
**Commercial and hand-treated cloth, thread, and yarn over armature of**
**fiberfill, wire, polystyrene foam, and plastic board | Machine reverse**
**appliqué, machine sewing and quilting; needle-sculpting and hand**
**assembly of 3-D elements |** Susan explains: "From the front of this piece,
the viewer sees only Rapunzel at the top of the tower and the prince beseeching
her from the ground below. Her hand is on her hair as she considers his request.
Looking down on the tower, one sees Rapunzel's hair winding around and flowing
through a trap door. From the back, however, the viewer sees an open door with
Rapunzel's hair trailing down the stairs to the ground. Courtship involves many
options and decisions!" *Photograph by Marty McGillivray*

sewing together of two sides of an arm or hand is done by machine. Once I stuff a body part I can no longer work on it with the machine. The assembly has to be done by hand. That's thousands and thousands of stitches."

When she begins a new piece, Else says, "I often have only the vaguest glimmer of an idea. I don't sketch. I do very little measuring. It's fairly organic and intuitive. I do trimming to make things fit. I'll make one element, and I will add other elements in the process. Sometimes I have to take things out. Sometimes I have to make things over. But I don't make a model. I do a lot of tweaking at the end—facial structure, gestures. They start out looking very stick-like, and I work with them to make them come alive."

**CONSUMER CONFIDENCE** | Susan Else | 2006 | 24" x 17" x 13" | **Commercial and hand-treated cloth, thread, and yarn over an armature of fiberfill, wire, and polystyrene foam** | **Machine reverse appliqué, machine sewing and quilting; needle-sculpting and hand assembly of 3-D elements** | "I love objects, especially beautiful ones," says Susan, "but at the same time I know that we're killing ourselves with stuff." The skulls on the surface of the figure are made from a transparent Halloween fabric Susan found at a hardware store, applied on top of a beautiful fabric hand-dyed by Judy Robertson. *Photograph by Marty McGillivray*

ADVICE FROM *Susan Else*

People should never be afraid to play and never be afraid to really get in there and solve problems. In really grappling with the work and being willing to go the extra mile, you get work that you don't expect. This has been like having a tiger by the tail. I have never known where it was going to lead me, especially in the beginning. Every piece I did led me to another piece. Be willing to go for the ride and don't have preconceptions about the kind of work you're going to do. It's important to be open and give it your all.

**LIFETIME** | Susan Else | 2007 | 39" x 20" x 14" |
Commercial and hand-treated cloth, paint, thread, and
yarn over armature of fiberfill, wire, and polystyrene
foam | Machine reverse appliqué, machine sewing
and quilting; needle-sculpting and hand assembly
of 3-D elements | Susan says, "I was always a skinny
person, but weight became more of an issue for me in
midlife." Once the figure was quilted and assembled, she
applied the blue/violet paint, covering the surface with
numbers and check boxes—"staples of many a nutritional
program!" she says. Intentionally, there are no numbers on
the scale. *Photograph by Marty McGillivray*

*Lifetime*, detail. *Photograph by Marty McGillivray*

**ABOVE THE BOARDWALK** | Susan Else | 2007 | 55" x 49" x 25" | Commercial and hand-treated cloth, thread, and yarn over armature of welded steel, polystyrene foam, plastic board, and fiberfill. Electric motor and sound system. | Machine reverse appliqué, machine sewing and quilting; needle-sculpting and hand assembly of 3-D elements. Engineering and underlying metalwork by Iman Lizarazu. | This piece was made for an exhibition celebrating the one hundredth anniversary of the Boardwalk in Santa Cruz, California, where Susan lives. The wheel is motorized and accompanied by a recording of Boardwalk sounds—furthering her contention that cloth can be a kinetic medium. *Photograph by Marty McGillivray*

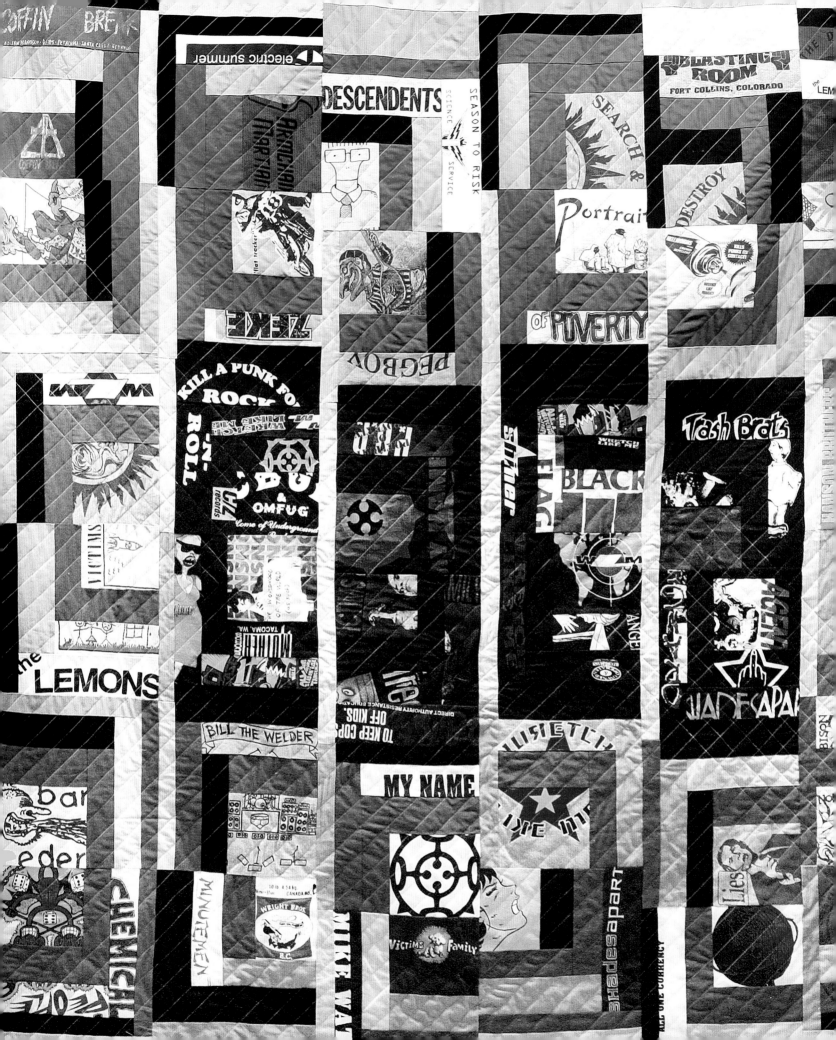

# Boo Davis

BOO DAVIS CALLS HER WORK *Evil Rock Quilts*, and, to be certain, she is not running the risk of taking home a county-fair blue ribbon anytime soon. Unlike most contemporary art quilters who employ cutting-edge techniques to make pieces intended to be hung on a wall, Davis is comfortable using variations of old-school patterns and creating utilitarian art. In other words, she's just fine with the idea of folks sleeping beneath her art. In fact, she would prefer they did.

Davis came to quilting the old-fashioned way, "cozied up under her grandmother's quilt." But instead of sipping hot cocoa and reading *Little Women* for pointers on how to be a do-gooder, her formative years included an Ozzy Osbourne soundtrack. "I had a cousin who was a metalhead, and she exposed me to a lot of stuff at an early age. She gave me a cassette of Ozzy's *Diary of a Madman*. I think it's encoded in my DNA."

For nearly a decade, Davis worked as a designer and illustrator for the *Seattle Times*, saving her alter-ego as Metalhead Craft Mistress for after-hours. Then, in early 2008, she took the plunge, got out her credit cards for self-financing purposes, and jumped head-on into the world of full-time textile artist.

"Rock 'n' roll quilts reinterpret old quilt traditions by putting an evil spin on things," she explains. "My favorite is a Log Cabin pattern—I like using that to represent a skull or devil horns or the Grim Reaper."

Davis is mostly self-taught, having picked up her early skills through reading books and hands-on practice.

**DAMAGED** | Boo Davis/Quiltsrÿche | 2006–2008 | 84" x 92" | Cotton and T-shirts | **Machine pieced and quilted** | For this ultimate punk rock quilt, Boo reinterpreted the four bars of the iconic Black Flag logo with a Half Log Cabin design. *Damaged* features fragments of fifty-one tees. This quilt took almost two years from start to finish, and was Boo's first attempt at quilting a queen-size quilt on her small sewing machine. *Collection of Abe Brennan. Photograph courtesy of Boo Davis/Quiltsrÿche.*

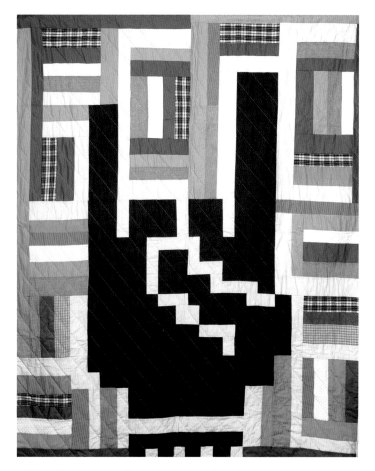

**BANGOVER | Boo Davis/Quiltsrÿche | 2006 | 60" x 72" | Cotton | Machine pieced and quilted |** The "devil horns" is the ultimate heavy-metal gesture, and Boo had to capture it with this Roman Stripes variation. *Photograph courtesy of Boo Davis/Quiltsrÿche*

"I didn't start quilting until college. I went to school in Chicago and spent most evenings indoors, since is it was so cold and miserable. A friend and I hung out and hand-stitched together. After college, a lot of my friends started having babies. That's when I got a machine and took some classes and started producing baby blankets at a steady rate.

"When I felt solid with my quilting skills, I started looking at things differently." Davis was thumbing through a book of artwork from the punk-rock movement when inspiration struck. "I was looking through some of the fliers in there and thinking how cool would it be to silkscreen that and incorporate it into my quilts. Then I went a step further and thought, *How about a heavy metal quilt?*"

Davis works in her dining-room-turned-studio in Seattle's Queen Anne neighborhood, listening to metal along with her cats, Dubba and Squirrel. "I thought about getting a studio space," she says, "but not only could I not afford it, my cats are a big part of my process, and I want them around all times. They keep me company through the long hours of quilting crazydom. They're always there to inspect."

Davis's design background plays heavily in her process. "I start with a sketch, to get a rough idea. From there I take it to the computer and do everything in Adobe Illustrator. I make it as simple as possible, but it's always a challenge, creating a pattern in the least number of unique pieces. I like things to be simplistic and look complex when I'm in the cutting and piecing process. That's where I mix things up, cut things short or long and hope for accidents. I approach it as collage. I really don't know how it's going to turn out in the end. I have no preconceived ideas. Serendipity is the only way I get anything good done."

Boo Davis, working in her home studio. *Photograph by Ori Sofer*

Boo affixes her personal label to all her work. *Photograph by Ori Sofer*

"I usually have to sew it and step away from it for a month to fully appreciate it. I'm pretty hard on myself. It takes some time away because I'm too close to it, and I stop seeing the beauty at some point. It's definitely like giving birth, this painful process. I go through this creatively every time. I berate myself and tell myself I'm a fraud that's going to be exposed at any moment, and then I push through and have this thing I'm proud of, and I've instantly forgotten the pain."

At which point she'll send the top out to a professional with a long-arm machine to finish it. Finding the right finisher can be tricky, given her themes and the titles she gives her work. "I ask up front, 'Do you have a sense of humor?' I tell them I'm not a Satan worshipper but I need this *God Bless the Children of the Beast* quilt quilted. . . ."

Not long into her foray as a full-time artist, Davis scored a book contract to compile some of her patterns. Again, she ran head-on into a heavy metal wall. Her agent showed it to publishers, who were impressed with her work but wary of offering patterns that might be considered too far out there. The proposal was ultimately accepted, but the publishers requested that Davis balance her radical work out with other offerings. "There will be a handful of rock 'n' roll patterns, and the rest will be more general and sweet."

As for color choices, this is another area in which Davis strays from tradition. "I tend to err on the side of ugly with colors. I like to make things challenging and not so pretty. Things you might not expect to go together like bright, hideous safety orange and some brown."

She spends over a hundred hours on each quilt top, time she admits she might streamline if she cut out the cat dances, but that's not a ritual she's willing to give up. Once a top is finished, she walks away from it for a spell.

ADVICE FROM *Boo Davis*

I'm a big fan of simple, straightforward quilting with lots of diagonal lines. I went to a hardware store and bought a five-foot-long piece of inch-and-a-quarter trim, and I put that on my quilt and draw lines on it. That's been a godsend. I was rigging up all sorts of other ways before I bought the trim.

As far as acquiring fabric, I'm a compulsive estate-saler. I think that's the way to go. If you don't have to set foot in a store, that's a brilliant thing. There's so much fabric out there already in the world. I think it's nice to create less of a demand.

**KNUCKLEHEAD** | Boo Davis/Quiltsrÿche | 2007 | 80" x 87" | Cotton with silk-screening | Machine pieced and quilted | This was Boo's very first design and is still her favorite quilt to make. It's a Half Log Cabin variation. *Photograph courtesy of Boo Davis/Quiltsrÿche*

**BASKETCASE | Boo Davis/Quiltsrÿche | 2007 | 80" x 87" | Cotton | Machine pieced and quilted |** Here are two of Boo's favorite things in a quilt: simple and sinister.

*Basketcase* is a Basketweave variation turned evil. As evil as you can get with a pink and rust color palette. *Photograph courtesy of Boo Davis/Quiltsrÿche*

# Karen Kamenetzky

THOUGH KAREN KAMENETZKY HAD BEEN an art major, the Vermonter's path took another turn, and she pursued a career in psychology after college. Still, she missed answering her muse. "I would sketch when my kids were little, but I was always frustrated that I wasn't making art," she says. "I loved being a mom and a therapist, but I was hungry for art."

In the late nineties, excited at the possibilities she saw in the work of quilt artists, she began studying their work and experimenting herself with dyeing fabrics. "I didn't even own a sewing machine and hadn't sewn on one since eighth grade home ec," she says.

She started out hand-piecing a bed quilt, adding embroidery as she went, and this experimentation brought her great satisfaction. "I loved the color and texture and fabric and freedom. I took what was traditional, and I changed it. I was unsatisfied unless I added something of my own."

Then, around 2000, Kamenetzky discovered Jane Sassaman's work. "She was using fusible web, cutting up pieces and collaging. It suddenly hit me that you could do anything you wanted, you weren't constrained by anything. I could do anything I wanted with fabric."

Then, another book brought further inspiration. This time, it was a collection by Lennart Nilsson, a Swiss photographer who captured images of fetuses in the womb. "It had electron microscopic photos of a seed germinating. I think my second piece came from that. I remember looking at a picture thinking, *These things are happening right now that make up our world. We don't perceive them but that's where it's all happening.* There's a spiritual component for me. That's where the fascination came from."

**FUNDAMENTAL CHANGE II | Karen Kamenetzky | 2004 | 20" x 41.5" | Artist-dyed cottons and cheesecloth, yarns | Machine stitched |** Karen Kamenetzky's inspiration often comes from microscopic, cellular images. In *Fundamental Change II*, she explains, "Shifts and slight variations alter the whole. Transformation is afoot." *Photograph by Deidre Adams*

**POTENTIAL III** | **Karen Kamenetzky** | **2004** | **24" x 41"** | **Artist-dyed cottons, yarns** | **Machine stitched** | Of the inspiration she finds in biology and the work she then creates, Karen says, "To me it's an invented biology. I've looked at lots and lots of images. I put them together. There's some sort of story in my head about a moment of change happening." In *Potential III*, she says, "Possibilities lie dormant but are ready to emerge when imagined." *Photograph by Ori Sofer*

From that point, she began searching online for cellular, microscopic images. "It was more interesting for me to look at plants because things like blood cells and nerve endings are almost cliché. These were new to me—phloem in a plant stem, how water moves through, that was amazing to me."

Though she didn't know what she was doing technically, Kamenetzky used the influence of these images to create her early works. "It's hard for me to look at those early pieces now," she says. "In some ways it's nice for me to see how my art has evolved. But I was making stuff up. The whole sewing machine I was trying to figure out. I started on a cheap machine—I used it up until a year ago when I got my prized Janome. That old machine was like driving a Pinto. It would screw up all the time, the needles would break, the thread would break. But I persevered."

She began producing bigger pieces in 2001, and a couple of years after that, she started entering national shows. "It terrified me showing my work to anyone but my family and friends. I got accepted to the first national show I applied to. That gave me confidence. The next show, Art Quilts at the Sedgwick, was very competitive, and I got in. That was 2004, and it was a real turning point for me in seeing myself as an artist—knowing this isn't a little thing I'm doing. I got a lot of feedback. My piece sold five minutes after the opening. My head was so big I couldn't get through the door. It was a great shot in the arm. I started to take myself and my art more seriously and thinking about investing in it and putting more concerted effort into marketing and learning how to do that."

Kamenetzky's perspective on shows changed in 2006 when she was diagnosed with breast cancer. "Up until then I would plan what shows I was going to enter. It was something I put a lot of time and energy into. I went through treatment—chemo, being bald, the whole nine yards. I'm fine now, but it shifted a lot of things in my life. I don't want to sound cliché about it, but it really did make me reevaluate a lot of things in my life—what's important and what's not and where do I want to put my energy? I realized that entering shows—for the most part it's a crapshoot and it's costly. The more I went to these shows I realized that most of the

audience are other fiber artists. There's something nice about that, but I don't want to just be part of this insular world."

She begins her process with white cotton and silk, using various kinds of dyeing and painting techniques to create pieces of fabric that have a lot of depth and texture. She then backs this fabric with Wonder Under, an iron-on fusible adhesive product used to attach pieces of fabric to each other, and stockpiles her stash. Next, she turns to her sketchbook.

"I do these sketches until I'm excited. I'll come up with something about the composition that really grabs me. There also has to be some story attached to it. People ask if I do abstract or realism. To me it's an invented biology. I've looked at lots and lots of images. I put them together. There's some sort of story in my head about a moment of change happening."

Then it's time to think about color. "I make a big mess, pull out all the fabrics," she says. "I start with a big piece of fabric, a little bigger than the finished piece will be. I cut and fuse. I tack it down and experiment. The finished piece always morphs and changes from the original sketch. I use free-motion machine stitching—to me the stitching is like drawing."

One thing Kamenetzky doesn't do is stitch through all three layers. "I only work through the front and a thin batting. I fuse a false back on and fold over the front edge without

Karen Kamenetzky in her studio. *Photograph courtesy of the artist*

batting so it's finished, and then I hand-stitch it. You turn it over and don't see the stitching. I do that because I'm not a meticulous stitcher. My sewing is loose, not straight and even. I'm in awe of people who have those finished backs, but I don't want to spend my time worrying about that."

ADVICE FROM *Karen Kamenetzky*

Up until 2008, I never took a class or workshop in fiber arts. I have read lots online and talked to other artists and read books and shared hints and ideas. I watch a lot of talented people get stuck in going to workshop after workshop. There are hundreds of techniques. Making art for me is not about just learning new techniques and trying them out, unless it's something I need to know to make happen what I want to make happen. I think there's a danger in getting pulled in different directions—you don't find your voice. You're not working through problems in your own way.

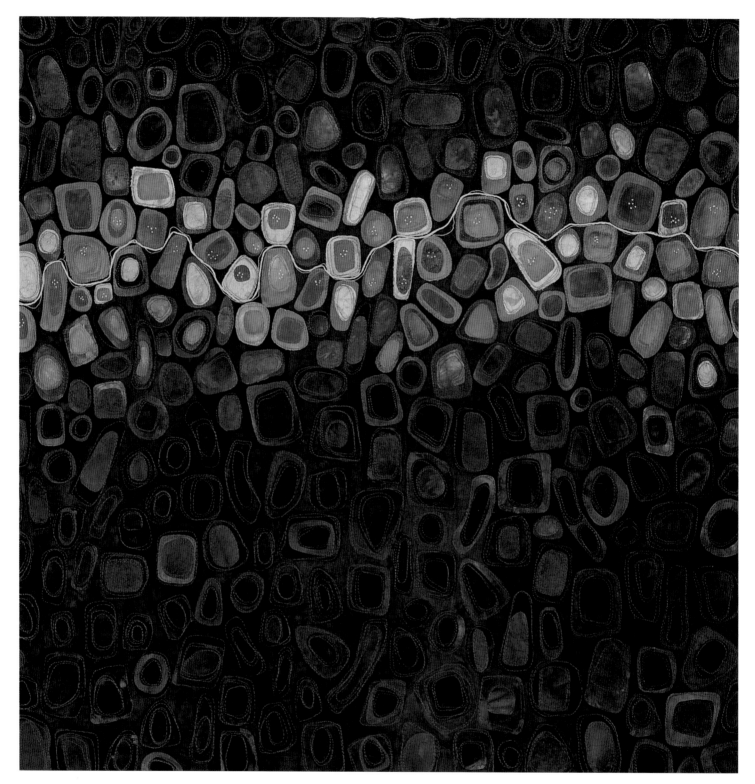

**LIFE GOES ON IV** | **Karen Kamenetzky** | **2008** | **30" x 30"** | **Artist-dyed cottons and silks, yarns** | **Machine and hand stitched** | This piece is part of a series exploring choices, obstacles, and the impact of paths chosen. Whether a river, a root, a conduit through cells, or a life; even minute choices alter our world. *Photograph by Laurie Indenbaum*

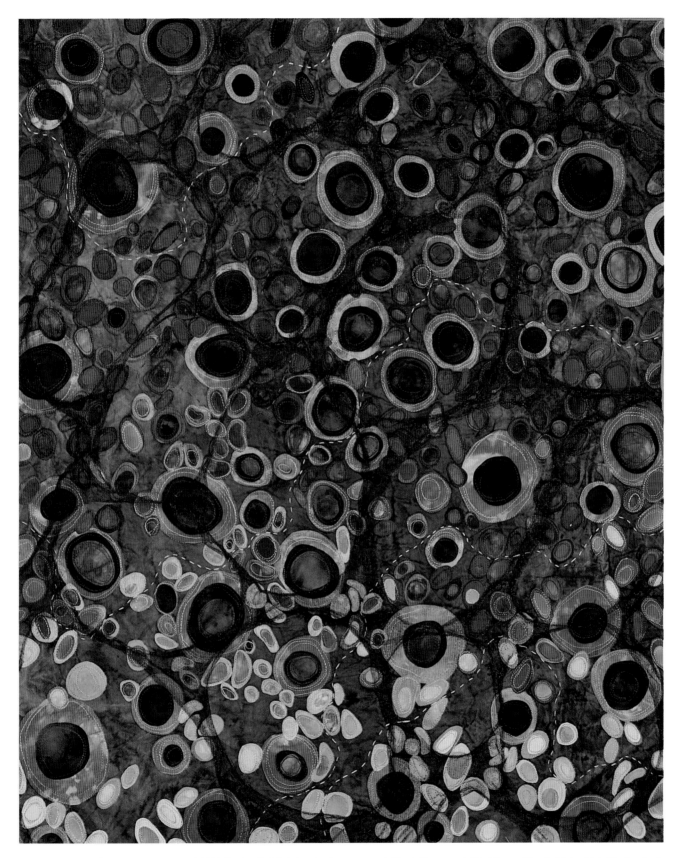

**BIODIVERSITY III** | **Karen Kamenetzky** | **2008** | **28" x 35"** | **Artist-dyed cottons and silks, tulle, yarns** | **Machine and hand stitched** | In *Biodiversity III*, Karen explores opposite ends of a spectrum that she describes as "wild, evolving change amid stable constants." *Photograph by Ori Sofer*

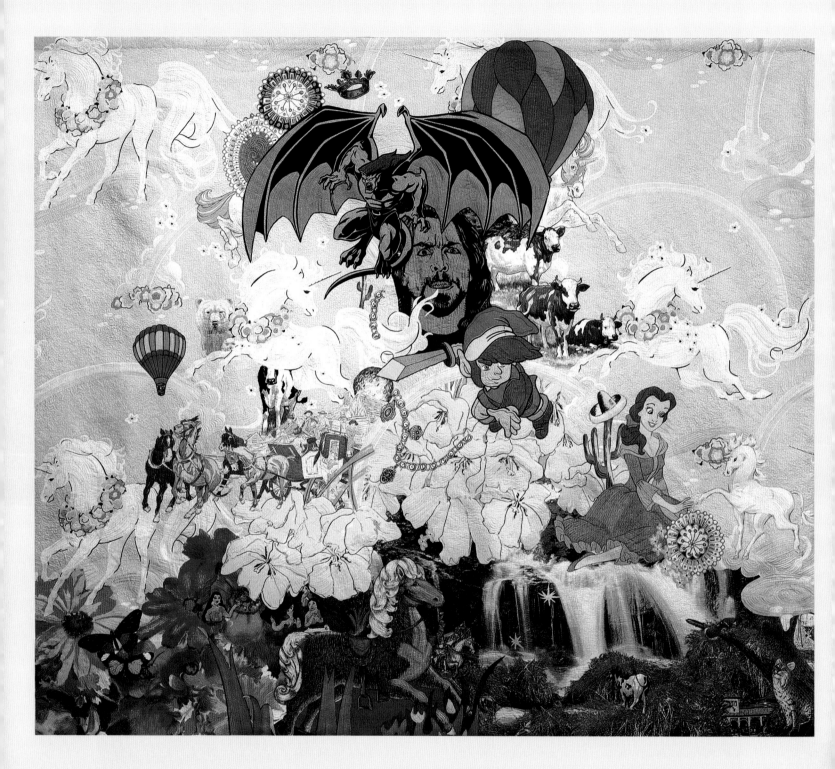

# Ai Kijima

AI KIJIMA'S WORK IS FUNNY, whimsical, and loaded with pop-culture icons: Princess Jasmine from Disney's *Aladdin* embracing Bruce Lee; Ronald McDonald sharing space with unicorns; Snow White holding court with a cheetah. She rarely uses new fabric, preferring instead to thrift shop or hit flea markets. Many of the components she uses in her collage quilts come from children's bed sheets. Fiber content covers a wide spectrum: nylon, polyester, silk, rayon, linen, blends, and cotton—nothing is off-limits.

Kijima grew up in Japan, where she did a lot of crafting as a child. She moved back and forth to the United States, living in different cities before settling in 2008 in a third-floor walk-up in Brooklyn, New York. When she was an undergraduate at the School of the Art Institute of Chicago, she focused on painting and photography but, indulging her love of fabric, did take some fashion/fiber classes and tried her hand at fabric sculpture.

"I was always involved with textiles. In my twenties I became more like a fiber artist. I studied weaving and natural dyeing with vegetable dyes. I was really into weaving but not much into quilting."

She made her first large quilt when she was twenty-five and living in Japan. This was followed by others, but the process was tedious. "It took so many hours to make a quilt. I was doing it all by hand using one-inch squares of rayon."

Completing her first large work, which is breathtaking in its beauty, scope, and detail (both front and back), brought mixed feelings. "I felt accomplished when it was finished. I also thought, *I can't do this again.*"

Still, she wanted to make a living with the things she made. So she switched to weaving for a while, eventually returning to quilting but in a radically different

**FINDING A UNICORN** | Ai Kijima | 2005 | 46" x 54" | **Found materials** | **Fused, machine quilted** | "I love unicorn tapestries in the Cloister's museum in New York," says Ai. "I wanted to make my version of unicorn tapestries here." *Collection of Troy Klyber. Photograph by David Ettinger.*

*Artist photograph by Ori Sofer*

form. Now quilting is her sole focus, and she works in her tiny studio, a converted back bedroom in her apartment that is both packed tight with a worktable and enormous stash, and amazingly organized and tidy.

Deciding which characters to mix with which other characters is sometimes "like an accident," she says, Jasmine and Bruce Lee being an example of this. "I just kind of grab intuitively," she says. "Sometimes I have something in mind, sometimes not. I have to use what fabric I have, and I can't paint or change colors or sizes. I have to just do it with what I have here. When I can laugh at the results, the piece is pretty successful, because I know other people will enjoy it, too."

Kijima generally fuses collage pieces directly to each other, rather than fusing them onto a large fabric top. The collaging takes place on the big table. "To work a larger piece, you can't put everything on the table, so I connect and connect them," she says, which requires bunching up the piece as she goes and then ironing it out, knowing that any little bumps will be taken care of during the quilting process and result in additional texture.

Once the top is completed, she uses very thin batting and, typically, a black back. For the quilting, she'll follow the patterns of the images on the front of the quilt and do countless closely placed rows of stitches. The result resembles something like a painting on the back, an extra piece of art as pleasing to take in as the front. "It's like a drawing," she says. "One time I had a show where my pieces were hung from the ceiling so you could see both sides."

**BULL | Ai Kijima | 2005 | 35" x 60.5" | Found materials | Fused, machine quilted |** Kijima generally fuses collage pieces directly to each other, rather than fusing them onto a large fabric top. The collaging takes place on her big table. "To work a larger piece, you can't put everything on the table, so I connect and connect them," she says. She made *Bull* for her first solo show at Peter Miller Gallery in Chicago. *Photograph courtesy of the artist*

Kijima shows her work in museums and galleries, doesn't belong to any quilt groups, and hasn't been to a quilt show in some time. But she's fine with using the word *quilt*. "My work is fused and quilted, so the technique is quilting. I don't mind that people call me a quilting artist. I don't care how other people try to describe my work, because they have their own points of view and backgrounds. I think of myself as an artist using quilting as my medium to express my vision. I am not interested in giving quilting a lower/higher status in the art hierarchy."

It took Kijima about a month to complete the top of the quilt on which Bruce Lee meets Jasmine. Of her process, Kijima says it's not unusual to spend 150 hours on a single piece. She's been able to sell quite a bit of her work but continues to work part time to supplement her income, noting that rent in New York is not exactly cheap. But it's where she wants to be, close to the gallery that represents her, and a better place for her to meet people—in New York she has had more studio visits from art dealers, curators, and clients than she did in Chicago.

She says, "I like pretty much everything," when it comes to process, though she still has her challenges. Of these—digging for the best finds at secondhand shops, forcing herself to work only with what images she is able to cut out from the printed fabric—finishing might be the biggest. "It's really hard to finish. My type of quilting is very small. I think

Ai Kijima's home studio. *Photograph by Ori Sofer*

I have a lot of patience because I did a lot of weaving and hand-dyeing and it took forever to dye yarns."

Despite the number of child-targeted icons in her work, her clients are typically older, drawn to her avant-garde style. Sometimes they request commissioned work. A number of indie rock bands have also asked her to do specific pieces as covers for their CDs. So far, she's turned down the requests, preferring to follow her own inspiration, without constraint.

ADVICE FROM *Ai Kijima*

Don't be afraid of using anything you want to use. I'm a pretty analog person. My machine is not even computerized, it's an old one. I don't mind because I don't really need a program. I don't use pattern quilting. I just follow images on the top fabric.

**CAKE WHITE PALACE | Ai Kijima | 2004 | 49" x 108" | Found materials | Fused, machine quilted |** Kijima shows her work in museums and galleries, doesn't belong to any quilt groups, and hasn't been to a quilt show in some time. But she's fine with using the word *quilt*. "My work is fused and quilted, so the technique is quilting. I don't mind that people call me a quilting artist." *Collection of Ernst Hilger. Photograph by David Ettinger.*

**PEACE ON EARTH, detail | Ai Kijima | 2008 | 100" x 63" | Found materials | Fused, machine quilted |** Deciding which characters to mix with which other characters is sometimes "like an accident" she says, Jasmine and Bruce Lee being an example of this. "I just kind of grab intuitively," she says. "Sometimes I have something in mind, sometimes not." She made *Peace on Earth* for her second solo show at Franklin Parrasch Gallery in New York. *Photograph by Ori Sofer*

**HOME** | **Ai Kijima** | **2006** | **25" x 36"** | **Found materials** | **Fused, machine quilted** | Despite the number of child-targeted icons in her work, her clients are typically older, drawn to her avant-garde style. Sometimes they request commissioned work. A number of indie rock bands have also asked her to do specific pieces as covers for their CDs. So far, she's turned down the requests, preferring to follow her own inspiration, without constraint, though *Home* came about when she agreed to do a poster and the theme was simply "home."

*Photograph by David Ettinger*

# Mary Louise Butters

MARY LOUISE BUTTERS IS FAMOUS in Austin, Texas, for her brownies. Which doesn't mean she isn't equally amazing at making art quilts—she is. In fact, in a sense, the brownies are an extension of the quilts, and both are a result of a lifetime of being drawn toward making life better, more beautiful, and totally tactile.

"I've always worked with texture," she says. "I can take a sunset and be inspired and turn it into a pie. I remember seeing the sunset through fields of sorghum and thinking, *I want to wear that*."

She was raised from the get-go to pursue crafts of all sorts. "I grew up hands on, I was raised by hand," she says. "It didn't seem abnormal at all to create your world around you. My mother was very laissez faire. In the kitchen, anything I was inspired to do, I could."

As an adult, she carried with her those early roots of making art with her hands. Quilts, in particular, called to her. "I could not get over that concept of finding little pieces of thrown-away life, which, if you pieced them together, you get something functional and something inspirational. The tiniest thing I could find—the wing of a butterfly—I could build a quilt around it."

She began taking classes to learn traditional quilting and get the basics down. Early on, she made a Mariner's Compass, which required complete precision, not one stitch off. That was the end of precision for Butters.

"The minute it came off my design wall I realized I could bend the rules now. Within three days I completely pieced a top. I had been dyeing the fabric. I did the shibori and the batik. *There* was my voice. With that quilt, I had jumped over the Grand Canyon. I went from *Do I have a voice?* to being on firm ground. It owned me."

At the time she was working in a gourmet grocery store and feeling very dead-end in that pursuit. "I'd gone to a New Year's Eve party and was asked to share

*Emancipation*, detail. Photograph by Ori Sofer

TIRAMISU | **Mary Louise Butters** | 2003 | 41" x 29" | **Hand-dyed, batik, and shibori-dyed pima cotton, found fabric, variegated thread** | **Machine pieced and quilted** | "This piece is a little pick-me-up for your kitchen," says Mary Louise. "That is the definition of *tiramisu* in Italian—a sweet little something to brighten your kitchen, to remind you texture and color doesn't only come in food." *Photograph by Ori Sofer*

was telling me what to do. My job was to show up and get into that river."

She realized, as she went, that doing everything by hand became less important to her. "At first I thought you have to have your hand in things, you have to have your blood from your fingers on it. Then I realized some pieces need the texture of the machine line. I don't plan it out. I use a variegated thread most of the time. I just do what the quilt tells me to do. If it's hand quilting, I do that."

Butters recalls that, during a particularly productive cycle, pieces seemed to complete themselves as long as she remembered to just stay in the flow. "My inspiration is where edges meet, where life seems to be ripped and when you put it back together, it's not at all lost—it's something beautiful."

That cycle lasted for a year, during which she was also moving toward a divorce and watching her father-in-law die. "The quilting was so healing. Working on them provided a space and time when I was part of something bigger than myself, I didn't have to control it, I gave myself over to it. It didn't have to make sense for me to keep going."

Divorce brought the transition from art studio to kitchen. "I needed more. My life was beginning to shift. I was in a marriage, and it was like a low-grade infection had set in. It suddenly crested. And my life became like the human experience of the perfect storm. At the same time all this was coming together I connected with friends who wanted me to

best and worst moments of the past year. I couldn't think of the best moment, and that's unusual for me—I get excited over belly-button lint. I thought, *That's it, I'm going to create a studio and cut out the bullshit and quit the job and follow what has been calling me.*"

She did quit her job and pursued quilting full time. "I started by finishing pieces I had started. Then pieces exploded out of my chest. It was effortless. I would go in the studio, and I could take that muse and all of these colors came out of me like a complete tune. I'd realize the quilt

Mary Louise poses in the kitchen with a box of her brownies and the *Tiramisu* quilt.

*Tiramisu*, details. Mary Louise Butters is as creative in the kitchen as she is in her studio. Here, those worlds collide in a quilt filled with food flourishes and culinary creativity.

*Photographs by Ori Sofer*

make something chocolate. I whipped up this recipe that had been given to me. When I gave them to my friends they said, 'Why are you not doing this for a living?' I thought, *Maybe it's time. If everything's going to change, why not change everything?"*

Soon, she altered the original recipe, given to her by a friend, eventually growing it to several recipes. "I completely bastardized it and made it my own. I was doing the same thing to the recipe that I was doing with the quilts. I recognized the mystery and beauty of chocolate, which is an incredible tool to express so many emotions. It's such a mysterious food. It's so dynamic. There's nothing static. I experience the same thing with the brownies as the quilts. It's more of a creative process with me and more intuitive. I have to answer to what it's telling me to do."

She started a very small business in her home kitchen, financed by loans. "I just started pulling money out of

the house. I was taking a risk, and it takes time to build something like this. Everyone wants a Cinderella story, but it doesn't happen that fast. I kept taking risks and taking money out of the house, throwing everything at the wall to see what sticks. For three years, without missing a single week, I baked, packaged, and delivered every single brownie that I sold."

Her persistence paid off. So far, her brownies have netted her invitations to the Sundance Film Festival and the Oscars. And she's appeared on the Food Network and *Rachael Ray*, all courtesy of word-of-mouth advertising about her creative magic.

"Food is a portal to joy," says Butters, who could just as easily be talking about her quilts. "It's connected to community and health, it's so multifaceted. I would love to see our culture embrace more of the joys of it rather than the dogma. Hence chocolate—it's a forgivable sin. No one questions whether or not you need it."

**ADVICE FROM** *Mary Louise Butters*

I would say there are a couple of ways of following your bliss. You can fling yourself off a cliff and as the wind rushes past wonder if your wings are opening or if you're free-falling. The other way is to say, "I want to get from here to here." They're the same thing as long as you're holding to the vision that you want to get there. There is a galaxy of ways to get there. It might be hard to let go of what you're familiar with. You can do it step by step. You can get there.

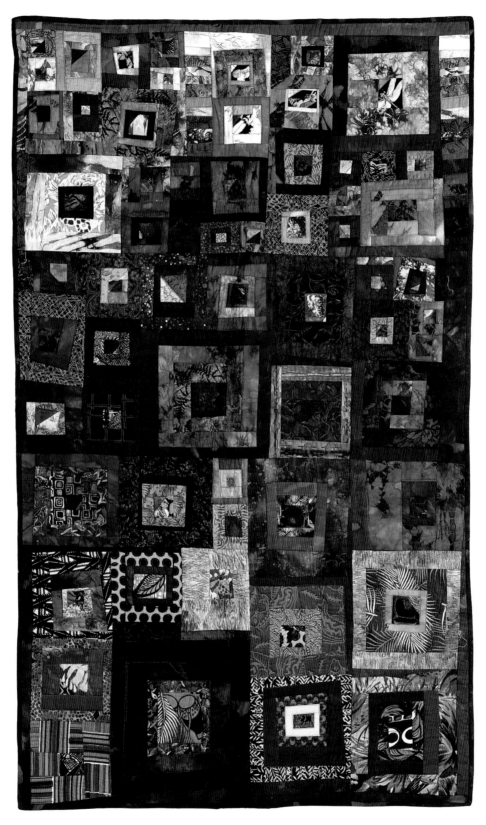

**VISUALIZING THE BLUES** | **Mary Louise Butters** | **2002** | **60" x 36"** | **Hand-dyed, batik, and shibori-dyed pima cotton, found fabric, variegated thread** | **Machine pieced and quilted** | This piece is one of a two-panel series. "I love this one," says Mary Louise. "When I listen to the blues, deep down, I hear a pulse and the rhythms of Africa. I listen to the blues to feel better, to find company on a path wide enough for only one. What is it they say?— 'The blues ain't nothin' but a good man feelin' bad.'" *Photograph by Ori Sofer*

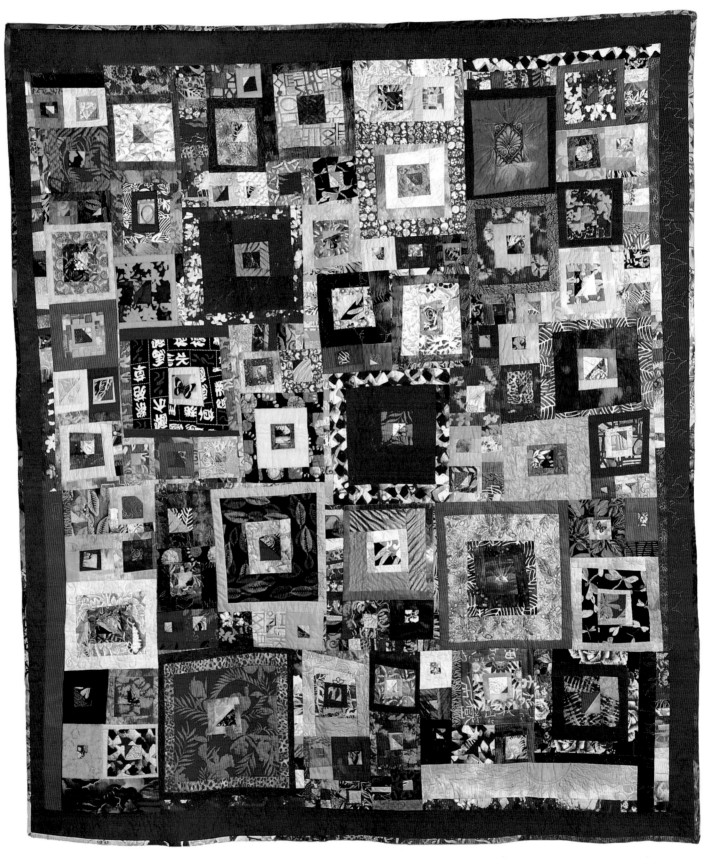

**EMANCIPATION** | **Mary Louise Butters** | **2001** | **76" x 86"** | **Hand-dyed, batik, and shibori-dyed pima cotton, found fabric, variegated thread** | **Machine pieced and quilted** | This quilt was inspired by Bob Marley's *Redemption Song*, specifically the lyrics: "Emancipate yourselves from mental slavery. None but ourselves can free our minds." Says Mary Louise, "This is about grounding yourself in your sense of your tribal roots in order to launch yourself into your spiritual destiny." *Photograph by Ori Sofer*

# Margot Lovinger

MARGOT LOVINGER BEGAN ART SCHOOL at Parsons School of Design in New York where she studied painting and art history. She admits that while she was really interested in figurative painting, she was not very good at it, an assessment with which her teachers unabashedly concurred.

"I'd do paintings, but I was so frustrated," she recalls. "I hated the results. The professors also hated the results. I had one professor who didn't know what to do with me. He'd just look at my work and go, 'Uhhh. Mmmmph.'"

Having someone wince and grunt at her work like that, even though she herself wasn't happy with the results, was not conducive to a joyful educational experience. So she switched to the Museum School in Boston, a fine arts college better suited to her artistic vision. There she focused on sculpture—steel and wood and glass—but also developed an interest in textiles. When she left school, she left behind certain resources she couldn't re-create at home, like, say, a steelworks studio. Textiles then became her focus, in part by default, since this was a medium she could work with in a fairly small space without needing expensive tools.

Lovinger's first forays into art quilts incorporated photo transfers and embroidery and told little stories that she describes as "fun and expressive, not particularly interesting to other people, but interesting to me."

The story quilts weren't enough, though, as she kept feeling pulled toward figure painting and had a strong desire to incorporate figurative art into her work. Then came her father's death and with it an artistic turning point.

"I was working on a huge quilt all about death. It was seven feet tall and had these huge wings on it sewn out of all different sheer fabrics. Ethereal colors. Each wing had thousands of feather-shaped pieces sewn on top of each other

*Awake*, detail. *Photograph courtesy of the artist*

*Artist photograph by Ori Sofer*

**AFTERNOON | Margot Lovinger | 2007 | 50" x 30" | Cottons, silks, and tulle, with beading and embroidery | Hand-sewn, layered fabrics |** "With this piece, I wanted to challenge myself to work in a much lighter palette than I usually choose, so I draped the figure and the bed she was on in different shades of white," Margot says. "I also wanted to see if I could capture the look of late afternoon sunlight falling across the figure, instead of opting for the darker, more starkly lit look that I have worked with in the past." *Collection of Nysha Nelson. Photograph courtesy of the artist.*

with beads. I'm not a very tidy person. My studio had stuff everywhere with piles and piles of sheer material. I'd look across the room, see some fabric, and say, 'That's the color I want,' only to find I was looking through layers of colored fabric, not a single piece. I realized then I could put layers of sheers on top of each other to manipulate the colors and I could get almost any color I wanted if I had a good starter palette. Also, if I put the layers in a different order they'd look different. I came up with an almost infinite palette."

Here, then, was a way for her to combine textiles with figure painting. Her first effort "wasn't great, but it gave me an idea of what I could do," she says. That was ten years ago. She's been refining her technique ever since. Even up close, except for being able to see the fine mesh of a top layer of tulle or organza, it's hard to believe her pieces involve no paint and incorporate so many multiple layers.

But because the sheers she uses are so fine, even if one area of a piece requires many more layers than another, the overall results appear even across the finished work.

The whole process typically begins with her camera, a friend willing to pose (usually nude), and possibly a bottle of wine for relaxation purposes—helpful, since Lovinger is likely to take two hundred photos in a single session. She uses very directed lighting to emphasize shadows, which are key to her fabric work.

"Then I'll pick elements from different photos and create a general image I want to work with. I'll print that up in variations, one with contrast all the way at brightest then at lowest end, in color and black and white." From there, she'll do a drawing on acetate or vellum, creating "a detailed map" of what the final piece is going to look like. This is projected onto the fabric with an overhead projector.

SURPRISE | Margot Lovinger | 2006 | 35" x 21" | Cottons, silk, netting, and tulle, with embroidery | Hand-sewn, layered fabrics | "In this piece, the challenge was to get the rose right. I had never done a flower before," says Margot. "The interlaced fingers were also a fun puzzle." *Photograph courtesy of the artist*

Then, as she works, she uses homemade light boxes to illuminate the fabric shadows and keep track of where she's at in the piece.

Once she begins working with fabric, "They start out looking like Matisse cutouts." Using *Cassandra* as an example, she points out various components. The figure's face began as a beige block on a purple "batik-y" background. For hair she found an orange fabric that already looked "so much like hair I felt like I was cheating." At the bottom of the piece there's purple rayon lace, some chiffon, and even some gold lamé she lifted from a tacky scarf someone gave her.

Once she has the basic blocks in place, she begins tinting the skin, a process during which she typically builds from darkest to lightest using only layers of fabric—no dye, paint, or bleach. Sometimes she fuses fabric. What stitching she does use is minimal.

Margot Lovinger at home with her detailed notebook of ideas. *Photograph by Ori Sofer*

**VOLUPTAS, details | Margot Lovinger | 2006 | 58" x 29" | Cottons, silks, rayons, upholstery fabrics, chiffon, netting, and tulle, with beading and embroidery | Hand-sewn, layered fabrics |** *Voluptas* means "satisfaction" or "pleasure" in Latin. Margot says, "I love the confident, bemused expression of the model here. Her body language speaks volumes. While I was making this one, I really enjoyed seeing how each successive layer of shadow caused the figure to appear to sink back deeper into the pillows." *Photographs courtesy of the artist*

Lovinger garners support and camaraderie from her fellow members in the Contemporary QuiltArt Association, a group of more than 120 quilters, mostly from Seattle. The group exhibits members' pieces in different galleries, and Lovinger shows with them whenever possible. Sometimes, though, her work will be shunned, not for the reason you might think—that some people would say her work is not really a "quilt"—but for another reason altogether: because much of her art features nudes and, yes, even today, sometimes a nipple revealed does not fly when it comes to public display.

"For CQA shows, I've gotten into the habit of only offering non-nudes," she says. "But for the most part I try to show places that aren't going to edit what I show. I used to have a policy that went—if they said they would love to show these pieces but not these pieces, I went along with it. Then I finally got to the point where I feel comfortable saying, 'Thanks, I'll show it someplace else.' I feel ridiculous having to edit my body of work, which I don't even think is that racy."

**LILYAN, details | Margot Lovinger | 2006 | 36" x 44" | Cottons, silks, rayons, lame, organza, chiffon, and tulle, with beading, sequins, and embroidery | Hand-sewn, layered fabrics** | Margot typically builds her pieces from darkest to lightest using only layers of fabric—no dye, paint, or bleach. Sometimes she fuses fabric. What stitching she does use is minimal. *Photographs courtesy of the artist*

ADVICE FROM *Margot Lovinger*

I would say the thing I've learned most recently is to not compromise my work for what I think is going to do well. I've come to this realization that what I do is okay, it's enough. In [the Contemporary QuiltArt Association], people would talk about, "Oh this has a blind facing" or refer to some specific stitch. I was always afraid they would find out I don't know how to sew "properly." But that's not true. I do what I do. It's still valid. It's worth not compromising about. I did one piece, a still life, because that's what I thought I "should" do—I was frustrated from not having sales. I thought maybe if I do different work and I'll have sales. So I did this piece, and it was boring to me, there was no passion in it. But it reminded me that I do what I do because it's what's interesting to me.

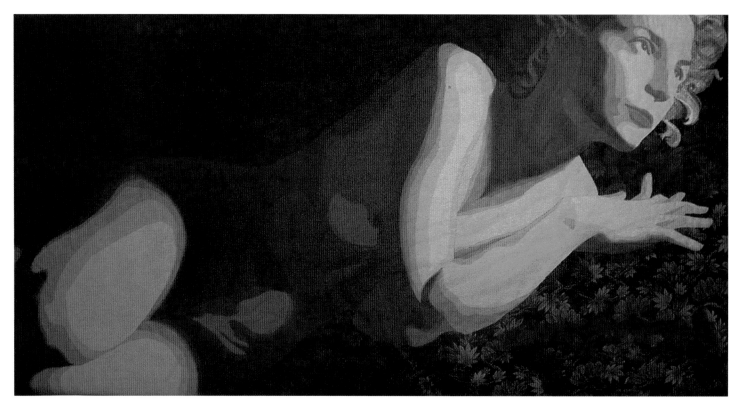

**AWAKE** | **Margot Lovinger** | **2003** | **57" x 29"** | **Cotton, netting, and tulle, with embroidery** | **Hand-sewn, layered fabrics** | Margot says, "I love the light in this piece. It was at this point that I was looking a lot at how Caravaggio painted light, and trying to learn from him." *Collection of Kevin T. Parent. Photograph courtesy of the artist.*

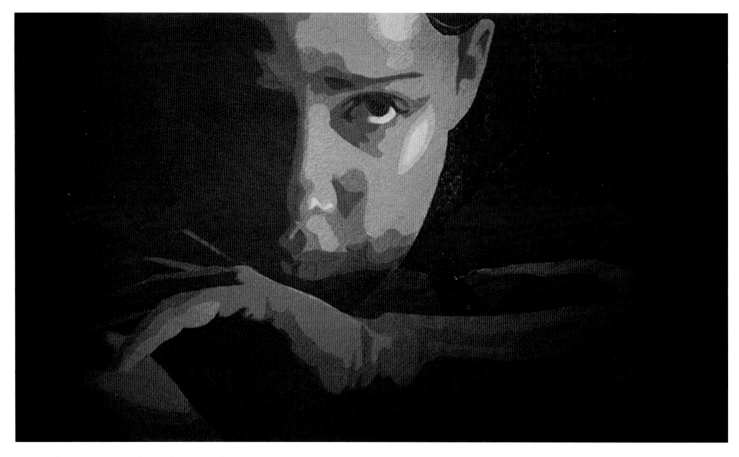

**CIARA 1** | **Margot Lovinger** | **2003** | **42" x 24"** | **Cotton, faux suede, netting, and tulle, with beading and embroidery** | **Hand-sewn, layered fabrics** | This piece represents an earlier version of Margot's current technique. "The model, my friend Ciara, has a great expression in this piece," she says. "There's a lot of emotion behind it, but I like that it's mysterious too." *Collection of Thomas Mnich. Photograph courtesy of the artist.*

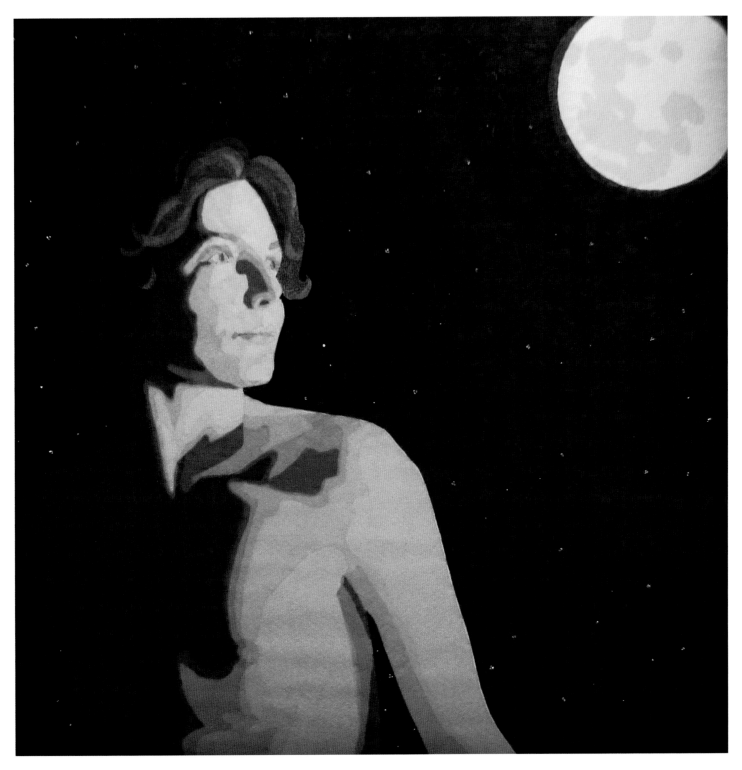

**MOON | Margot Lovinger | 2007 | 33" x 33" | Cottons, satin, organza and tulle, with beading and embroidery | Hand-sewn, layered fabrics |** For Margot, this piece was all about trying to capture the moon and the moonlight. "I used sparkle tulle in her skin tone to make her shine slightly in the moonlight. The moon consists of multiple layers of shimmer organza and sparkle tulle." *Photograph courtesy of the artist*

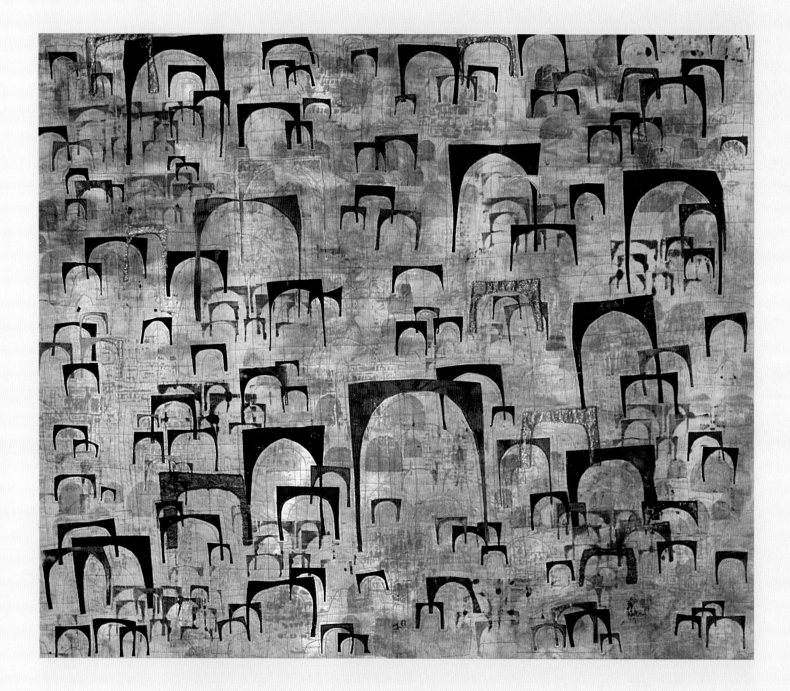

# *Joanie San Chirico*

THOUGH JOANIE SAN CHIRICO BEGAN sewing lessons at nine and took drawing and painting classes in high school, it was only about fifteen years ago, when the New Jersey artist adopted a son from Guatemala, that she thought to combine the two.

"I made my first quilt when we were waiting for him," she says. "It was a yearlong process. Even the first quilt wasn't traditional."

But it was inspirational, jumpstarting a business selling adoption quilts to other families adopting children from foreign countries. "The quilts were kind of cartoony looking, featuring a kid from whatever country the adopted child was from, wearing ethnic outfits from that country," she says.

She did very well with that endeavor, but success had its drawbacks. "I was really at that point where the adoption quilts were taking time away from my art. I said, 'I can't do this anymore. I can't do another Chinese girl or Russian girl.' It was rote, the same thing over and over." So she sold the business and refocused on her fine art.

San Chirico refers to her work as mixed-media textile art, with an emphasis on *mixed*.

She might start painting something on paper, which will then get scanned, photocopied, and applied to fabric. Or she might add stitches to a painting. Once, she created a twenty-two-foot stage backdrop made of recycled jeans for a New York City restaurant. "My work is a whole hybrid," she explains.

Unlike some artists who feel stifled creatively by commissions, San Chirico welcomes them, in part because they pay well. "Commission work and selling my

**CATACOMBS XIII: AFTER KLEE | Joanie San Chirico | 2005 | 37" x 44" | Cotton, dye, paint | Hand dyed and painted, appliquéd, machine stitched |** "My *Catacombs* series is not yet finished," says Joanie. "So far, I have made twenty-two pieces and I still have sketches for more. Every time I think I'm done, I see something, a building perhaps, and that leads me to other permutations of arranged arches." *Photograph courtesy of the artist*

work is validation for me. If people want to spend their hard-earned money on it, that feels like good work," she says.

But, though she is well known and sought after, and her work appears regularly in galleries, sometimes factors she can't always pinpoint cause fluctuation in demand. "What's bizarre—three years ago I did a large commission for a library. I did really well that year and well again the year after that. And then I totally tanked. And then this year, even with the economy as bad as it is, I'm getting one job after another."

Though slowdowns might be inexplicable, there's an easy explanation—beyond the fact that San Chirico produces beautiful pieces—when business picks up. She is known among her peers as the uber-queen of networking. She's

worked hard (and continues to work hard) to make the connections necessary to shine attention on her work in a market where you can't flick a wet paintbrush without splattering at least a half-dozen fine artists.

"I don't want people to think they can say, 'I'll be a commissioned artist!' and boom, they are. I started out volunteering at my local artists' guild and other organizations I belong to. I've done PR, have been gallery manager, and have created websites. And I've curated shows all over the place. All of that grows your networking circles bigger and bigger and bigger."

San Chirico is also a master of online connections. In addition to a website, where she blogs and displays her portfolio, she belongs to numerous online communities.

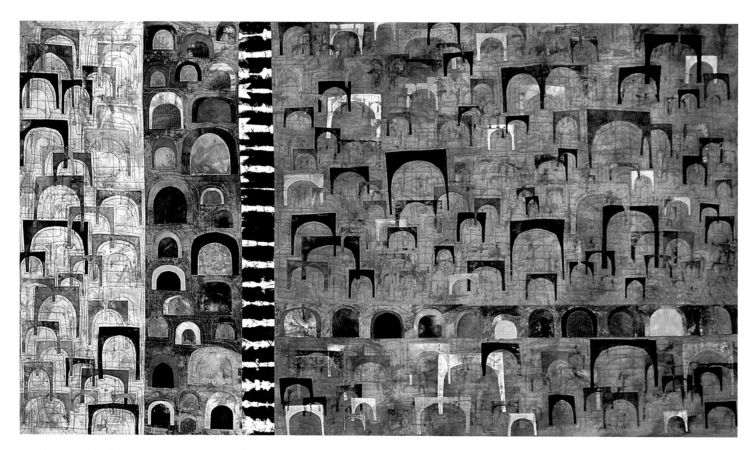

**CATACOMBS XVII: BABYLON** | Joanie San Chirico | 2006 | 37" x 68" | Cotton, dye, paint | Hand dyed and painted, appliquéd, machine stitched | "Many archeological sites have been obliterated as a result of war or the flooding of sensitive areas caused by the building of hydroelectric dams in the constant search to fill the world's need for energy," says Joanie. "When I read about the destruction of yet another archeological site, such as the sensitive digs and ruins at Babylon, I feel compelled to make another piece in the series."
*Photograph courtesy of the artist*

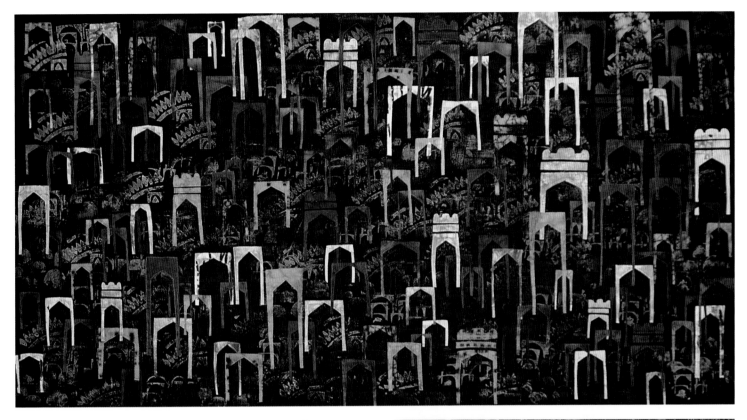

CATACOMBS XIX: PARIS | Joanie San Chirico | 2007 | 40" x 76" | Cotton, dye, paint | Hand dyed and painted, appliquéd, machine stitched | Arches are a regular theme in Joanie's work. She explains, "The arch is a symbol from antiquity that I use in my work to depict this integration of historical icon in modern contexts." *Photograph courtesy of the artist*

"I wouldn't be anywhere without the Internet," she says. "I've been on since its inception."

She likes to have a couple of series going at once. One of these, her *Catacombs* series, features multiple arches that draw the viewer into the work. "I always wanted to be an archeologist. My work is in layers," she says, by which she doesn't mean merely the three layers typically associated with quilting. "They're like an archeology dig. Most have a patina of age to them, like they're worn. I use different techniques—printing, paint, thread. Layers and layers."

Another series is her *Ritual Cloth* series about her cancer experience. "I think that series is done now, because I'm fine," she says. "Making it was something that helped me through. I had fallopian-tube cancer, which

affects three in one million. I made the first piece before I was diagnosed, but I was in pain. That has a lot of red slashes. The second piece, I knew I had it. The middle is red and angry, outside is blue and accepting. Then the next one was about chemo. There's a building on fire and a lot of flame imagery. That's the one a large hotel chain

**RITUAL CLOTH III | Joanie San Chirico | 2006 | 49" x 39" | Silk, paint, dye | Hand dyed, printed painting, hand and machine stitched |** Of her *Ritual Cloth* series, Joanie says, "I paint with acrylic paint on paper and take photos of those paintings or portions of the paintings. These enlarged images are then digitally printed on silk. The pieces are heavily hand-stitched for added texture." *Photograph courtesy of the artist*

wanted me to use as inspiration for a commission. I said, 'Do you realize that's a building on fire?' They didn't see that. Nobody would know what the series is about just by looking at it. People say, 'That's part of your environmental series.' It's good—not that the cancer influence was a secret but that the work was for me. I like when people interpret it themselves. The last one in the series is about the black holes left in my brain after chemo."

Having cancer changed her technique. "I don't do discharge dyeing anymore after cancer. I don't want to be exposed to any chemicals. I'm trying to avoid toxic processes. I have figured out how to achieve the same effect digitally. Instead of paste or bleach, I use Photoshop and Painter."

Having cancer also changed San Chirico's perspective, inspiring her to seize the day. "I used to put off plans. But you know what? Now, if I want to go to Italy, I go to Italy."

**RITUAL CLOTH II | Joanie San Chirico | 2005 | 62" x 34" | Silk, paint, dye Hand dyed, printed painting, hand and machine stitched |** *The Ritual Cloth* series is a documentation of Joanie's experience with cancer. "I had fallopian-tube cancer, which affects three in one million," she says. "I made the first piece before I was diagnosed, but I was in pain. That has a lot of red slashes. The second piece, I knew I had it.... Then the next one was about chemo." *Photograph courtesy of the artist*

ADVICE FROM *Joanie San Chirico*

Networking is number one. Some examples: I met a gallery owner from Toronto who wants to rep me. He found me at LinkedIn. A consultant firm in Atlanta found me through my website, and I just did a large commission for their client. The New York stage backdrop job came from another artist. Also, go to museums and study art other than quilts. Don't take a technique workshop unless you want to expand your stitching repertoire. Take a painting or drawing class. Even if you think you're not getting anything out of it, some little spark will be there. A lot of it is education—educate yourself.

**RITUAL CLOTH IV | Joanie San Chirico | 2006 | 43" x 90" | Silk, paint, dye | Hand dyed, printed painting, hand and machine stitched |** Though inspiration came from her personal life experiences, Joanie says, "Others have noted that the series relates to the destruction that man creates in the world through war, neglect, or disregard for the environment." *Photograph courtesy of the artist*

**RITUAL CLOTH V | Joanie San Chirico | 2007 | 43" x 88" | Silk, paint, dye | Hand dyed, printed painting, hand and machine stitched |** *Ritual Cloth V* is another in the series of work in which Joanie explored her cancer experience. "I think that series is done now, because I'm fine," she says. "Making it was something that helped me through." *Photograph courtesy of the artist*

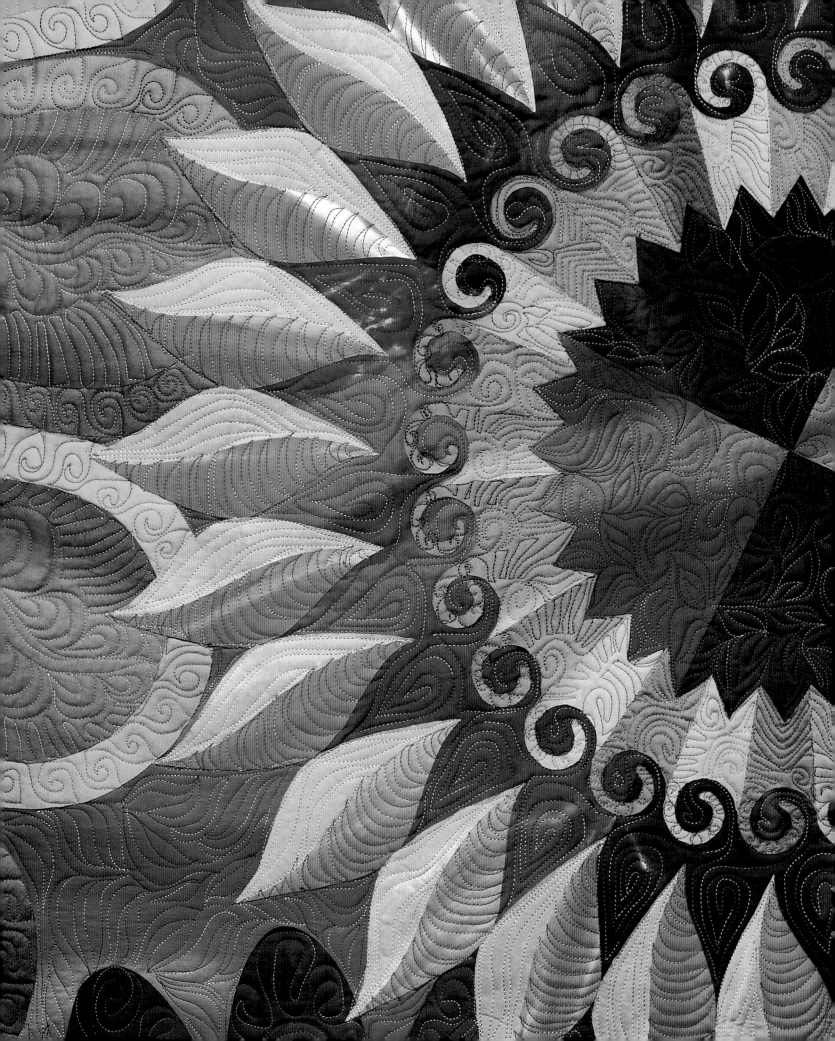

# Robbi Joy Eklow

AS ROBBI JOY EKLOW RECOUNTS in the opening chapter of her book, *Goddess of the Last Minute*, she is certain that her "addiction to all things fiber happened very early." Her grandmother, with whom she lived for a spell when she was little, was her earliest, greatest influence. Grama, as Eklow called her, had a thing for knitting. She also had an old sewing machine to which she introduced her granddaughter, not realizing that she was planting the seeds of creativity that continue to bloom, four decades later.

"I started sewing clothes when I was in kindergarten," Eklow recalls. She didn't always hem or finish her work—perhaps foreshadowing the innovative work she would come to do with her art quilts, which feature lots of raw-edged, fused appliqué.

Inspired by a friend in high school she observed working on a quilt, Eklow decided to try her hand at the craft. She never finished that piece, but she tried again four years later. It was 1980, and she and her husband had just graduated from college and were living in Chicago during a winter so cold they were forced to stay inside most of the time, leaving her plenty of opportunity to sew.

This time, quilting clicked. Several years and classes later, Eklow was taking quilting much more seriously. And then, after seeing her first big show in Paducah, she observed the entries, and she says, "I realized my quilts could be as good."

So she started entering competitions. She also began teaching classes, getting off to a curious start. A shop hired her and then, "They called me a week before my first scheduled class and asked me to teach that night," she remembers. "So I had to teach for the first time with about three hours notice."

A little over a decade ago, Eklow started to explore fusing, beginning with a quilt-guild challenge project. Of that experience she says, "The whole thing was terribly tacky, but I won a bunch of fabric, and my career in fusing was launched."

*Fantasy Flowers, detail. Photograph courtesy of the artist*

Robbi uses Adobe Illustrator to sketch potential motifs before beginning a new quilt.

**FANTASY FLOWERS | Robbi Joy Eklow | 2006 | 53" x 70" | Hand-dyed cottons, wool batting | Fused appliqué, unmarked free-motion quilting |** This quilt, made out of leftovers from two other quilts Robbi was working on, won two ribbons in 2006: Second Place, Innovative at the Denver National Quilt Festival and Second Place, Art-Abstract Large at the IQA World of Beauty in Houston, Texas. *Photograph courtesy of the artist*

Taking design inspiration from European magazines, she began delving further into fused appliqué and ditched commercial fabric in favor of fabrics she dyes herself in her basement.

"I free-motion quilt heavily," she says, "but I don't cover the edges. I don't think edges have to fold over. Some people get upset about fraying. I try to minimize fraying, but fraying happens. Still, free-motion holds layers on. It's not like someone is going to pull one thread and the whole thing is going to fall apart."

Lately, Eklow has been working on geometric designs, using Adobe Illustrator. "Some are complex," she says. "There are layers of spirals, and I'm cutting and intersecting them."

Her palette is heavy on the vivid and sparse on the muted. "I'm very childlike in my color selection," she says. "I love color—vibrant color. I'm a short, chubby person, and I would look ridiculous if I was wearing a lot of bright colors, but I put whatever I want in my quilt. Even when I try to make a toned-down quilt, it'll end up bright."

"When I first started quilting I was looking at a lot of Amish quilts. My kids were little and wearing winter clothes—back then the snow pants and stuff were patchwork-style with bright colors. I started noticing how happy little kids' clothes were. So my color schemes were informed by children's ski wear from twenty years ago," she says, and laughs.

Regardless of what else she has going on—teaching, making class samples, writing her column for *Quilting Arts*

**GROOVY GUITARS TOO!** detail | Robbi Joy Eklow | 2008 | 40" x 55" | Hand-dyed cottons, wool batting | Fused appliqué, unmarked free-motion quilting |
This quilt includes stylized versions of all kinds of guitars, including electric, acoustic, and bass. "I thought it was more fun to have cartoony shapes than realistic instruments," says Robbi. *Photograph courtesy of the artist*

*Magazine*, working on a book—her mind, she says, is always thinking about whatever quilt she's working on. "If I'm in the process of making a quilt, I try to concentrate on that," she says. She'll go into her studio in the morning and try to work until at least noon before running errands or tending to other work. "If I can, I put off other things," she says.

"I like to follow my own voice when making a piece," she says. "The only constraint I'll put on it is size. I want my work to at least qualify for the larger quilt category."

Size also factors in as a practical side of quilting that makes it appeal to Eklow more than other art forms. "I think one reason I make quilts as opposed to some other form is that I can make a quilt six or seven feet tall. Then I can roll it up and put it in my closet or send it to a show. If I did paintings that large, I wouldn't have anywhere to put them."

She aims to make at least two large quilts every year—"So I have one for Houston and Paducah," she explains. She'll also try to make some smaller quilts. It's not always easy hitting her goals, since her teaching and writing also demand attention.

"My column in *Quilting Arts* is always about quilting but not how-to," she says. "For example, I was packing a quilt to send to a show and I was using a *lot* of tape because I'm so frightened the shipping company will lose a quilt. So I wrote about that. Instead of getting therapy, I celebrate my neuroses and phobias in my writing."

**ADVICE FROM** *Robbi Joy Eklow*

My best advice is to find your own vocabulary of images to use in your quilts, so that your quilt is your quilt, not a copy of someone else's. Don't worry about what someone else will think of your quilt. Make quilts that you like. If you like them, chances are other people will too.

**NIFTY NINE PATCH** | Robbi Joy Eklow | 2008 | 60" x 60" | Hand-dyed cottons, wool batting | Fused appliqué, unmarked free-motion quilting | "I designed a line of fabric for Quilting Treasures a few years back and developed these motifs," says Robbi. "I liked them so much I blew them up and made them into a quilt." *Photograph courtesy of the artist*

**TERRA COTTA | Robbi Joy Eklow | 2006 | 65" x 81" | Hand-dyed cottons, wool batting | Fused appliqué, unmarked free-motion quilting |** This quilt was inspired by the terra-cotta ornamentation on old buildings in Chicago, Robbi's hometown. *Photograph courtesy of the artist*